IMAGES
of America

SALT LAKE CITY
CEMETERY

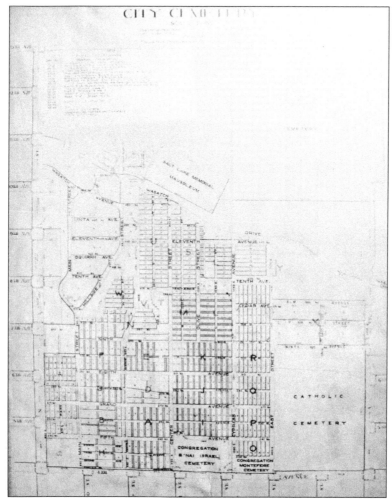

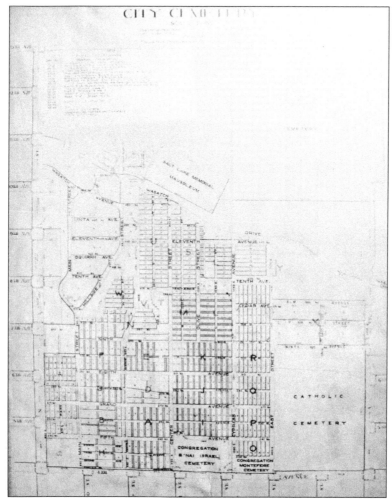

The Salt Lake City Cemetery is a city in stone set on a hill. Its grounds are full of art, happiness, sorrow, and unique individual stories of success, mystery, family, and accomplishment. Graves are surrounded by diverse flora and fauna set against the backdrop of some of the most breathtaking views of the Salt Lake Valley. This historic map depicts an early layout of the cemetery; visitors are advised to visit the sexton's office, at the corner of N Street and Fourth Avenue, and pick up a current map to best navigate this expansive site. Most captions in this book include burial locations, which can be found using one of these maps, and during business hours, cemetery staff is available to assist as well. Locations consist of the plat name, which is easily identified on cemetery maps, followed by the lot, block, grave, and tier to further specify placement. (Courtesy of the Salt Lake City Cemetery.)

ON THE COVER: The cover photograph shows gravesites located in Plat A and is an example of how cemeteries have evolved over the years, with some elements changing and others remaining the same. Strolling through the Salt Lake City Cemetery, the difference between this book's antique photographs and the present is noticeable. Looking at the cover, readers will get a glimpse back in time. They will see former styles of decoration using ornate flowerpots and hanging baskets. The same stones may remain standing over 150 years later, but their looks and the appearance of their surroundings, cemetery visitors, maintenance equipment, and key infrastructure have all changed with the ages. (Courtesy of the Utah State Historical Society.)

IMAGES
of America

SALT LAKE CITY
CEMETERY

Sexton Mark E. Smith with
Corey Rushton and Annastasia Hirt
Foreword by Mayor Jackie Biskupski

ARCADIA
PUBLISHING

Copyright © 2018 by Sexton Mark E. Smith with Corey Rushton and Annastasia Hirt
ISBN 978-1-4671-2946-6

Published by Arcadia Publishing
Charleston, South Carolina

Library of Congress Control Number: 2018937021

For all general information, please contact Arcadia Publishing:
Telephone 843-853-2070
Fax 843-853-0044
E-mail sales@arcadiapublishing.com
For customer service and orders:
Toll-Free 1-888-313-2665

Visit us on the Internet at www.arcadiapublishing.com

*This book is dedicated to cemetery visitors past, present,
and future whose personal quests for knowledge and
meaning draw them to these historic grounds.*

CONTENTS

FOREWORD

The discovery and preservation of history has long been central to Utah's culture and identity. This unique exploration of the past and the lives of those who came before us has not been solely focused on prominent figures or left to academics; rather, it is a tradition central to family life in this state. Today, visitors from around the globe come to Salt Lake City to research their own family history, to discover how they are connected to the world, and to hear stories of ancestors who helped build the places we call home. It is here where everyday lives are treated as extraordinary.

The staff at the Salt Lake City Cemetery carries on an unbroken legacy of preserving a critical piece of the history of this area. Their work caring for the resting places of the most extraordinary individuals who have lived here—including Martha Hughes Cannon, the first woman state senator and a personal hero for me—brings great pride to our city. But it is remembering that the most important person they are caring for is the one currently in front of them, whether living or dead, that makes them among the most dedicated public servants we have.

As you enjoy this book, and hopefully a visit to the Salt Lake City Cemetery, please remember this space is not merely a place of remembrance. Whether someone visits to run, walk, read, or to pay their respects, the Salt Lake City Cemetery is where this community has come for generations to celebrate the beauty of life and the incredible place we get to call home.

—Mayor Jackie Biskupski

ACKNOWLEDGMENTS

The authors wish to thank the Salt Lake City Public Services Department for its support of the cemetery and belief in its importance for future generations. The hard work of the department's Parks & Public Lands Division to produce a cemetery master plan aimed at sustainability and preservation is a key aspect of this valued support; the authors recognize with great appreciation the continued planning efforts of Nancy Monteith and the leadership of Parks & Public Lands director Kristin Riker. The support and encouragement of Public Services Department director Lisa Shaffer has been crucial to the master planning process as well as to the creation of this book. The authors are extremely grateful to all of these dedicated colleagues.

Several historical experts have donated their time and research skills free of charge to assist in finding the interesting historical photographs within these pages. The authors are grateful to Linda Hilton for her passionate research into the Salt Lake City Cemetery and the creation of a beautiful guide and map that precedes this book. Lorraine Crouse, with the University of Utah Marriott Library, and Claire Olsen, with the Daughters of Utah Pioneers' Pioneer Memorial Museum in Salt Lake City, have extended major support to this project by assisting the authors with their research.

Unless otherwise noted, all images are courtesy of the Utah State Historical Society. Other photograph sources include the Salt Lake City Cemetery private photograph collection (SLC Cemetery), the University of Utah Marriott Library Special Collections (Marriott Library), the Daughters of Utah Pioneers (DUP), and the incomparable guru collector of Utah history, Ron Fox (Fox). All photographs that are not from the Utah State Historical Society are cited parenthetically.

Finally, and most importantly, a heartfelt thank-you goes to the staff of the Salt Lake City Cemetery. The help of Kim Cardenas, Brandi Madrill, and Robyn Partlett throughout the writing of this book has been essential. We also thank the dedicated groundskeepers and maintenance staff who are on the job year in and year out keeping the cemetery running and well-maintained for all who visit, mourn, and lie in rest.

The authors are grateful to those interested and curious readers whose diverse interests in the Salt Lake City Cemetery demonstrate the importance of maintaining and preserving this living history museum far into the future.

INTRODUCTION

Newly arrived in the territory then called Deseret, a grieving father named George Wallace searched the Salt Lake City foothills for a place where he could lay his daughter Mary to rest away from the crowded pioneer burial grounds but close enough for him to easily visit. One can only imagine his sorrow when setting out to find this place. Wallace's thoughtful selection of a beautiful and peaceful hillside overlooking the Salt Lake Valley is evidence of how much his little girl's short life meant to him, and in burying her there, he laid the foundation for what is now the Salt Lake City Cemetery.

Mary Wallace died in 1848, just a year after Mormon pioneers first settled in the Salt Lake Valley. The Salt Lake City Cemetery was formally opened the same year, with George Wallace, fittingly, serving as its first sexton. In the 170 years since he laid his daughter to rest, the cemetery grounds have remained in continual operation and expanded from 20 acres to approximately 120 acres, where more than 124,000 individuals have been buried at the time of this book's publication. The cemetery continues to grow, with approximately 34,000 additional burials expected to be conducted in future years and more than 900 remaining burial rights for sale. No other municipal cemetery in the nation can match the Salt Lake City Cemetery's combined record of longevity, total number of burials, and overall size.

Resting on a bench above downtown Salt Lake City and at the edge of the historic Avenues neighborhood, visitors to the Salt Lake City Cemetery are afforded some of the best possible views of the entire Salt Lake Valley and the Wasatch and Oquirrh Mountains. At its southwestern entrance, the sexton's residence and gate stand as landmarks for the property. Within, the grounds are an urban forest, with roughly 3,000 trees of 42 species planted along roadsides creating peaceful paths throughout the grounds. These trees provide a cool respite for visitors and the diverse wildlife that quietly roams the cemetery, namely deer, fox, moose, and dozens of bird species.

Of course, all of the individuals featured throughout this book may be visited at the Salt Lake City Cemetery, residing together with these calm trees and elegant animals. Given that the earliest European settlers of Utah were Mormon pioneers, many leaders and influencers of The Church of Jesus Christ of Latter-day Saints are chronicled in this book. These individuals rapidly built a thriving community and shaped the history not only of their religion but of the entire region. However, the cemetery is nondenominational and also reflects Utah's diversity with a plethora of fascinating figures from different religions and walks of life, as well as monuments and burial areas for international communities, veterans, and workers' groups.

Although this book identifies a particular group of notable individuals, readers should remember that these are only a small part of the cemetery's 130,000 total burial plots. This book highlights distinguished individuals and monuments—people whose names stand out in Utah's history books. Yet there are thousands upon thousands more whose lives made a powerful impact on others, on their families, and on the communities they served. Because these pages cannot contain every individual's story, the hope remains that cemetery visitors will walk through its grounds and sense the tapestry of human connections formed by the thousands of graves within.

The absence from these pages of one grave in particular may perplex readers: "Emo's Grave," or the grave of Jacob Moritz. The urban legends surrounding Moritz, including how he received the nickname "Emo," are difficult to trace. We do know, however, that he was an extremely popular individual, embraced by area Mormons, and was successful as the proprietor of the Salt Lake Brewing Company. The omission of Moritz is for several reasons, including the fact that his remains were removed from the mausoleum and reinterred elsewhere.

As a reminder to those who enjoy this unique and amazing place, please remember to show proper respect. While cemeteries are part of everyday life, when visiting them, everyone should remember to respect both the living and the dead. Many are often confused or unsure of cemetery rules and basic etiquette; these are posted near each entrance and throughout the grounds. Also, remember to check and observe floral regulations. Cemetery grounds are open 365 days a year from 8:00 a.m. until dusk. Office hours and hours of operation can be found on the official cemetery website.

Do not touch any monuments or gravestones without permission to do restoration work. Some older memorials can crumble with even the slightest touch. Never remove anything from a memorial, like flowers, coins, stones, and other objects that have been left by family. When visiting the cemetery by car, follow the roadways, watch out for pedestrians and people who may not be paying attention, drive slowly, and remain off the grass. If the lane is narrow and another car approaches, offer to move your car until they can get through. Do not bring dogs or other pets into the cemetery. Children are encouraged to visit the cemetery, but parents are advised to keep them nearby and not to let them play on any of the monuments. This is not only disrespectful but may cause damage to the stone. Teaching children to have respect for any cemetery is encouraged. While it is an important open space, a cemetery is not a playground and should not be treated as such.

If a funeral is occurring, consider visiting at another time. Never block or impede funeral processions. It is considered extremely impolite to take pictures of strangers at a funeral. These individuals are in mourning, and their privacy should be respected during their time of grief. Always strive to be respectful by keeping voices low and avoiding bad language; people may be within earshot seeking solace. As a general rule, it is best not to approach strangers, as they may prefer to be left alone within the peace of their surroundings; of course, it is perfectly acceptable to offer help to anyone who is seemingly in need. Do not talk on a cell phone, as voices tend to carry in open spaces and down hillsides. Also, turn off car stereos while driving or parking in the cemetery. Do not leave any trash behind in the cemetery. Litter shows disrespect to those who come to visit the cemetery as well as to the caretakers. Report incidents of vandalism or theft to the police or the cemetery office. It is an unfortunate truth that people come to vandalize or steal from cemeteries.

These rules and guidelines not only maintain the peace and order necessary in managing this hallowed public space but also help everyone who passes through the cemetery gates to have a much more enjoyable experience.

Those who administer and guide the operations at the Salt Lake City Cemetery firmly believe that cemeteries are for the living. They encourage readers of this book to use it as a guide and have included the details of each individual's grave location in most captions. The cemetery was laid out in a grid style similar to the streets of Salt Lake City. Each location consists of the plat, lot, block, grave, and tier where each individual is buried. During business hours, cemetery staff is available in the sexton's house to assist visitors with navigating the cemetery grounds, conducting genealogical research, or providing further detail about historical figures buried there.

Individuals from different walks of life are interred in the Salt Lake City Cemetery, and the grounds are officially nondenominational. However, because of the location and natural beauty, other religious groups established cemeteries adjacent to the Salt Lake City Cemetery. Visitors to these cemeteries should be mindful and respectful of any additional customs, rules, or hours of operation.

The Salt Lake City Cemetery's future as a resting place for the deceased and as a living, continually growing museum for Utah history has been addressed by the creation of a master plan in 2017. With this plan, cemetery staff and members of the Salt Lake City Public Services Department Parks & Public Lands Division aim to expand access to and enhance appropriate uses of the cemetery, making it more of a multiuse facility for the community to enjoy and appreciate. The cemetery currently performs an average of 400 burials a year, and at this rate, it will be performing burials for more than 80 more years. While the cemetery staff has identified and implemented innovative ways to offer families remaining burial options that allow for the continued use of existing graves, it has fewer than 900 graves left for sale in its inventory. It is estimated that the cemetery will be out of saleable graves within the next five years, but the responsibility to perpetually care for the grounds will remain. The 2017 cemetery master plan will also guide the preservation and management of the cemetery and address its financial sustainability moving into the future.

Those who have the privilege of being a part of the Salt Lake City Cemetery and preserving its history often feel honored in their responsibilities. A sign that sits in the main office reads: "The difference between ordinary and extraordinary is the little extra." Each and every day, when family, friends, and visitors come in need of their services, they strive to give the little extra to make sure those needs are met.

Three words commonly used by cemetery staff are stewardship, obligation, and preservation. These words embody qualities that cemetery staff endeavor to live. At the end of the day, those involved want to be able to pass on to the next generation of caretakers a love for the cemetery that has been an integral part of this community since Salt Lake City was first settled.

Some will be interested in reading this book as a companion to visiting this remarkable cemetery and using it as a guide. Others will set it on their reading tables as a reminder of their interest in local history or to remember to locate a past family member or research a historical figure of interest. Others will find inspiration through this book to simply visit the Salt Lake City Cemetery more often and linger in reflection and enjoyment of the varied flora and fauna featured there.

Cemetery sexton Mark Smith is often asked "Who is the most important person buried in the Salt Lake City Cemetery?" and his answer is always the same: his great-grandfather. He always follows that up by saying that the most important person to them should be their ancestors, or whomever they've come to the cemetery that day to visit or research.

Cemeteries are for the living. Come to them often to take advantage of what amazing places they are and what they offer. Cemeteries are a historical record written in stone of what was, what is, and as we all know as time goes by, what is to come.

See you at the Salt Lake City Cemetery!

One

EARLY HISTORY OF THE SALT LAKE CITY CEMETERY

The Salt Lake City Cemetery was permanently established with the incorporation of Salt Lake City in 1851, although it began operations in 1849 and had its first burial in 1848. George Wallace, a recently arrived pioneer, conducted that first burial in what would become the cemetery grounds for his young daughter Mary, who died in 1848. In order to accommodate the need for burials in the growing pioneer city, Brigham Young appointed a committee to acquire 20 suitable acres. Wallace recommended the land and went on to become the first sexton of the Salt Lake City Cemetery. As sexton, Wallace was responsible for maintaining burial records, directing groundskeeping and maintenance, overseeing cemetery staff, and handling the finances of the cemetery. In its early years, the cemetery's acreage and burials expanded alongside population growth in the Salt Lake Valley. Infrastructure such as irrigation, retaining walls, and roads were built on the grounds; the sexton's house was constructed and, a few years later, redesigned; and an entrance gate was erected that remains standing to the current day. These foundational activities, directed by 31 sextons beginning with George Wallace, have sustained the Salt Lake City Cemetery's growth and development from its early years to the present day. This chapter seeks to highlight and chronicle the series of events following the sad burial of 17-month-old Mary Wallace and how they laid the foundation for the largest current municipally operated cemetery in the United States.

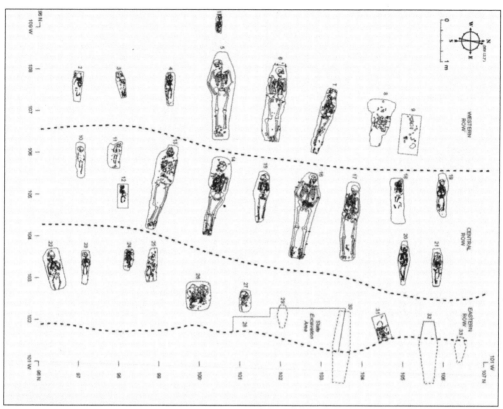

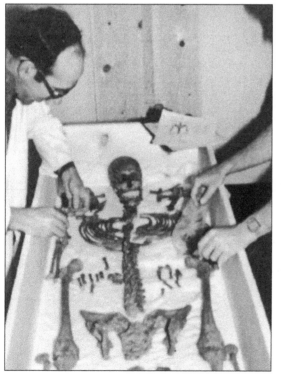

Before the Salt Lake City Cemetery was established in 1851, many Mormon settlers buried their dead one block east of the old fort at modern-day Pioneer Park. Utah's first pioneer burial site, designated as Block 49, began with the burial of three-year-old Milton Therlkill in August 1847. In 1986, construction unexpectedly unearthed the 33 graves of Block 49. At left, archeological work is being performed and documented on remains found at the site. Native American remains found at Block 49 were given to the Paiute Tribal Council for reburial, and all others, including the remains of Milton Therlkill, were reinterred at This is the Place Heritage Park in Salt Lake City, according to the above archaeological map of their original burial configuration. (Both, courtesy of Brigham Young University.)

Mary Melissa Wallace (Plat C-6-8-4-W) was the first person buried in the Salt Lake City Cemetery. She was born in Winter Quarters, Nebraska, on January 8, 1847, while her parents were trekking westward to Utah, and she died of diarrhea in Salt Lake City on September 27, 1848, as seen below in the official cemetery death record. Mary's father, George B. Wallace, buried her in a peaceful location northeast of the early pioneers' valley settlement, land that grew to become the official Salt Lake City Cemetery. Mary Wallace is buried with her brother George B. Wallace Jr. and many other family members, as represented on this grave marker in a lot owned by George B. Wallace. (Both, SLC Cemetery.)

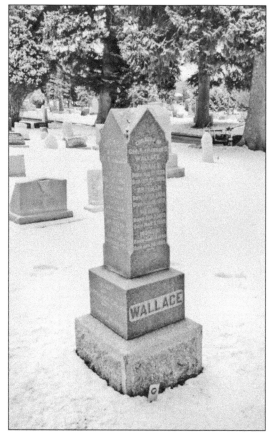

George B. Wallace (Plat R-9-3-1-E) arrived in Utah in 1847 as cocaptain with Abraham O. Smoot of a 223-person group of Mormon pioneers. When his young daughter Mary died one year later, Wallace conducted the first burial in what would become Salt Lake City Cemetery by laying her to rest on the current grounds. He maintained burial records as others also buried their loved ones on the property and was part of a committee with Daniel H. Wells and Joseph Heywood that recommended the property be named Salt Lake City's permanent cemetery. The committee's recommendation was adopted, and the Salt Lake City Cemetery was established in 1849. George Wallace was named its first sexton, charged with the leadership and management of all cemetery operations, a post he held for 15 years. Between Wallace's tenure and 2018, thirty-one individuals have served as Salt Lake City Cemetery sexton. (DUP.)

Joseph E. Taylor was the owner of the Utah Coffin and Casket Company and the Salt Lake City Cemetery sexton from May 1864 to May 1888.

Robert Patrick was an early Utah pioneer who emigrated from Scotland in 1863. He was the cemetery's fifth sexton and a member of the Salt Lake City Council.

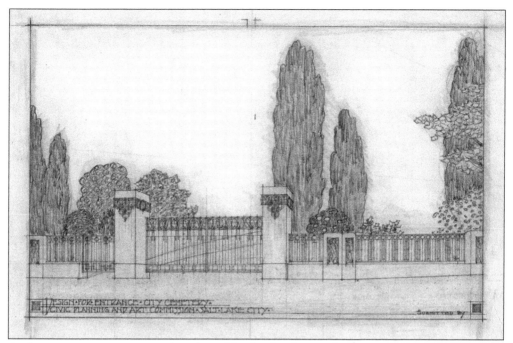

A planning contest was opened to the public for the design of entrance gates at the Salt Lake City Cemetery on the corner of Fourth Avenue and N Street. Thirty-five entries were submitted, including this rejected design, but only one was selected and brought to life.

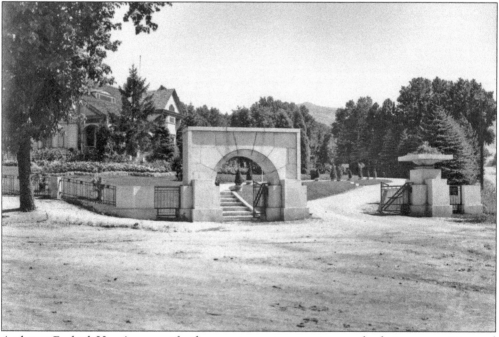

Architect Fredrick Hurst's concept for the cemetery entrance gates won the design competition and a $35 prize. The gates were erected between 1915 and 1916 with $2,000 budgeted for construction. Costs ran high, and it ultimately took $2,882.64 to complete the project. The gates still stand today, with a plaque commemorating the cemetery's establishment in 1848.

Standing just beyond the iconic entrance gate, the cemetery sexton's house was built in 1909 in the Victorian style seen here as a full-time residence for sextons and their families. In 1916, the exterior was redesigned with a lodge aesthetic. The old carriage house is visible to the rear of the property.

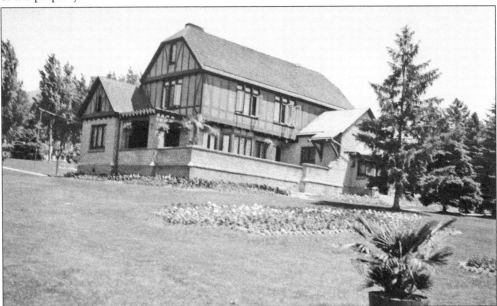

Pictured in 1917, the sexton's residence overlooks the iconic entrance gate and unpaved paths and roadways. By this time, trees and shrubbery planted in the cemetery, many of them evergreens, were flourishing, and the adjacent hillside had nearly become a forest. While the exterior remains the same today, the building interior was remodeled and converted to improved office space for cemetery staff in 2002. Mark E. Smith, who has directed the cemetery from 2002 to the printing of this book, was the first sexton or caretaker who did not reside full-time on the cemetery grounds.

Kept within the records vault of the sexton's office are handwritten volumes known as records of the dead. These books contain a historical treasure trove of information about all individuals interred at the Salt Lake City Cemetery, beginning with Mary Wallace and stretching to the present day. Among the vital statistics kept for each individual is the cause of death, which includes noteworthy historical and period causes including mountain fever, Indian shootings, and consumption. One record even lists a cause of death by "apple tree." (SLC Cemetery.)

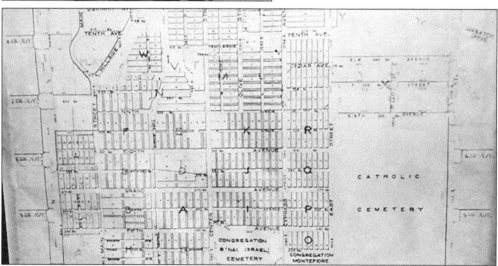

The Salt Lake City Cemetery keeps location records for each of the more than 124,000 individuals currently interred. Like Salt Lake City, plats have been developed as the cemetery has grown. Cemetery plats vary in size and are subdivided into blocks and lots for identification. Tiers identify whether the burial is located on the east or west half of the lot. Thus the grave location sequence is: plat, block, lot, grave, and tier. This detailed system of recording provides efficiency in recordkeeping and operations and also assists visitors with navigation. (SLC Cemetery.)

This photograph of the Salt Lake City Cemetery was taken in September 1917. The road seen next to the Barratt Monuments (Plat Park-8-14) is now gravesites. Throughout the cemetery, as the need for more gravesites arose, the city reclaimed some of the less-used roadways and turned them into burial plots. The last roadways converted into gravesites were changed on July 5, 2006.

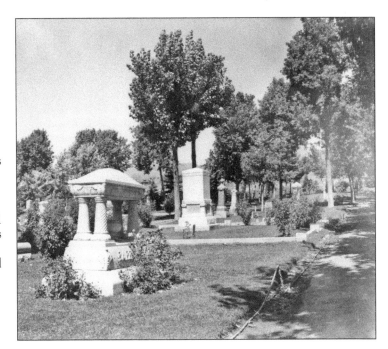

In the late 19th and early 20th centuries, municipal cemeteries were increasingly viewed more like public parks where people could go not only to visit the deceased but also to recreate in nature. This photograph shows an unidentified group from that era enjoying a sunny outing in the Salt Lake City Cemetery. (Marriott Library.)

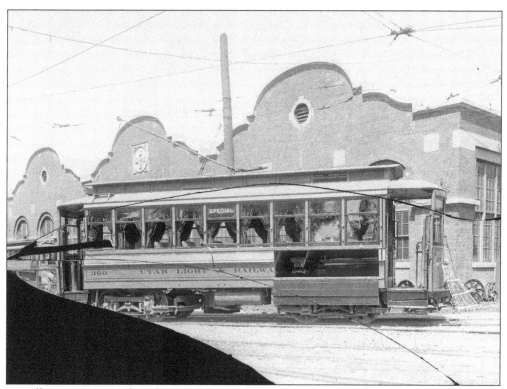

A trolley once operated in the Avenues neighborhood running from east to west on Second Avenue. Visitors to the Salt Lake City Cemetery could hop on a trolley and arrive just two blocks south of the main cemetery entrance on the corner of Fourth Avenue and N Street. Trolleys also ran to the Mount Olivet Cemetery. This trolley, specially outfitted with black drapes to transport funeral mourners, is pictured in 1913 at Trolley Square.

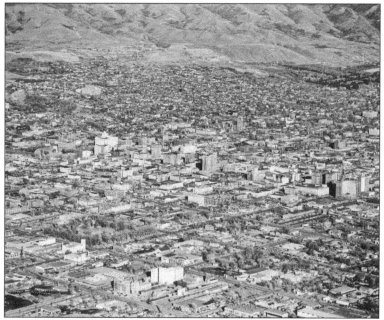

In this 1959 aerial photograph of Salt Lake City, the cemetery grounds can be seen at upper right: a darkly colored, forested section of land abutting the foothills that almost appears to be in shadow from all the spruce trees and greenery within.

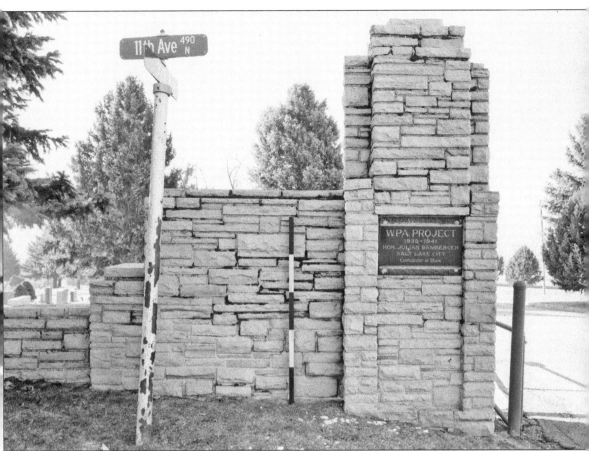

The Works Progress Administration (WPA) was a large part of the New Deal, an initiative of Pres. Franklin Roosevelt's administration that aimed to create jobs for the millions of Americans who were unemployed due to the Great Depression. In 1938, the WPA proposal to construct a wall surrounding the Salt Lake City Cemetery was approved; the project was completed in 1941. On the Eleventh Avenue cemetery entrance gate, plaques recognize the work of the WPA as well as railroad entrepreneur Julian Bamberger's contribution of the stone used to build the wall. (SLC Cemetery.)

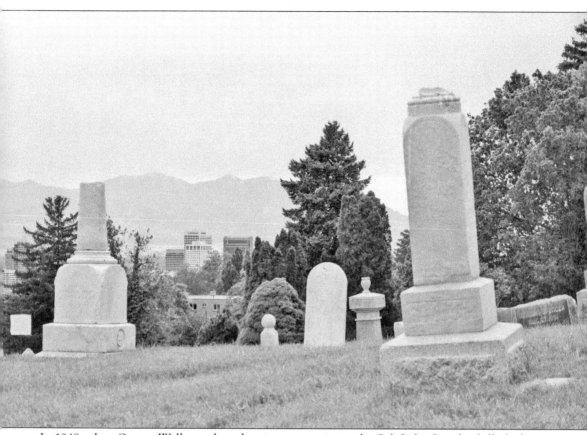

In 1848, when George Wallace selected a picturesque site in the Salt Lake City foothills for his daughter Mary's grave, he did not know that the location would be officially designated the Salt Lake City Cemetery only a few years later. As sexton, Wallace likely did not imagine that the 20-acre cemetery he oversaw would grow into a 120-acre cemetery containing 130,000 burial sites either. Since it became municipally governed in 1851, the cemetery has grown, diversified, and changed along with the skyscraper-dotted valley it now overlooks. In 2018, the cemetery had only 900 burial sites left for sale and is obligated to perform burials for another 24,000 presold plots. A master plan has been compiled outlining strategies to sustain maintenance of the Salt Lake City Cemetery for years to come. Through its long and varied history, the cemetery's serene atmosphere full of history remains constant, as does its commanding views of the Wasatch and Oquirrh Mountains. (SLC Cemetery.)

Two

NATURE IN THE CEMETERY

The Salt Lake City Cemetery spreads across a 120-acre expanse of hillside in the northern reaches of Salt Lake City. Although the grounds are surrounded by the residential Avenues neighborhood and are close to the vast University of Utah campus, over the years since its establishment, the cemetery has remained a peaceful urban oasis. Birds such as great horned owls, hawks, turkey vultures, and western tanagers can be sighted amongst the branches of fir, mimosa, sweet gum, maple, giant sequoia, and cedar trees. These varieties of trees and many more make up a true urban forest within the cemetery bounds. The cemetery's proximity to mountain foothills also leads wildlife to visit: fox, mule deer, and coyotes are regularly seen, with occasional moose and elk. Rising beyond the cemetery are impressive views of the Wasatch and Oquirrh Mountains, among Utah's most widely recognized natural landscapes. The Salt Lake City Cemetery is not just a resting place for the dead, nor is it solely a historic site; the cemetery is one of Salt Lake City's most significant green spaces, open to the public 365 days a year free of charge. Over the decades, the cemetery has had a profound effect on the health of the local ecology and the well-being of the surrounding and visiting public. Visitors cherish the opportunity to connect with nature at the Salt Lake City Cemetery, and many return regularly to walk, jog, or bike among its flora and fauna.

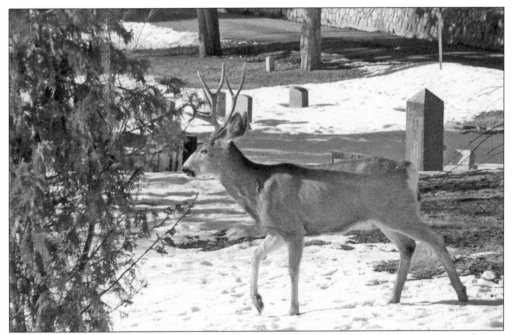

In all seasons, mule deer inhabit and visit the Salt Lake City Cemetery. While some live full-time within cemetery boundaries, others spend only winters there and retreat to the nearby foothills in summer. Year-round, they are typically seen in multigenerational groups, silently grazing and roaming between headstones. (SLC Cemetery.)

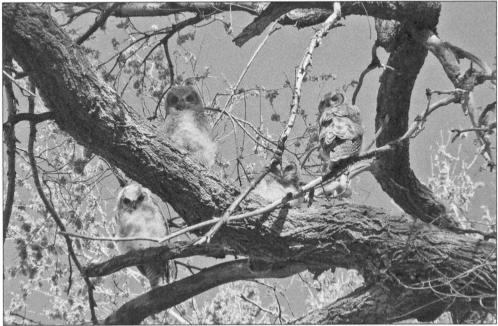

The Salt Lake City Cemetery is a popular and unique location for birding. Great horned owls are the largest owl in Utah and have resided in the cemetery for years. The species does not build their own nests. Instead, they take over the nests of other birds early each year and hatch their offspring by late April. (SLC Cemetery.)

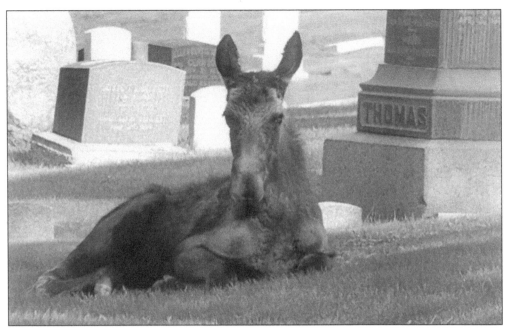

A rarer sight in the cemetery are moose, which come from the open lands bordering Salt Lake City. Moose typically travel solo or in pairs and, as the largest member of the deer family in Utah, can reach up to 1,200 pounds and six feet tall. Salt Lake City Cemetery visitors are cautioned to stay calm and maintain a safe distance when viewing these special creatures. (SLC Cemetery.)

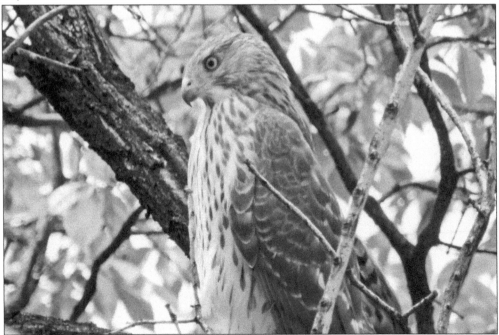

Red-tailed and Cooper's hawks can be seen in the highest reaches of the cemetery trees. As they raise their families, it is fun to see the young birds learning to fly. Some fortunate visitors have reported seeing the young hawks jumping and flying from headstone to headstone. (Courtesy of Casey Clark.)

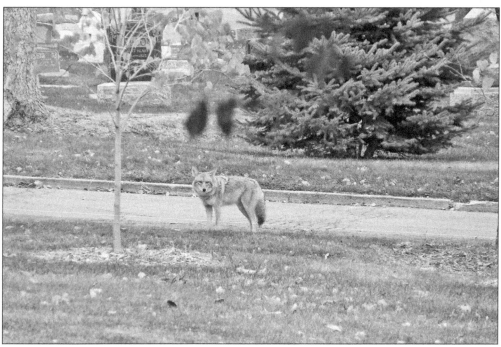

Coyotes and foxes are the only canine species that can be seen in the Salt Lake City Cemetery, as pet dogs are not permitted on the grounds. While coyotes are more active at night, when the cemetery is closed, fox sightings by daytime visitors are very common. On occasion during the spring, some will witness baby foxes playing by their dens. Neither animal is especially dangerous to humans, as they keep to themselves and avoid confrontation, but they are wild and should not be pursued or provoked. (Above, SLC Cemetery; below, Casey Clark.)

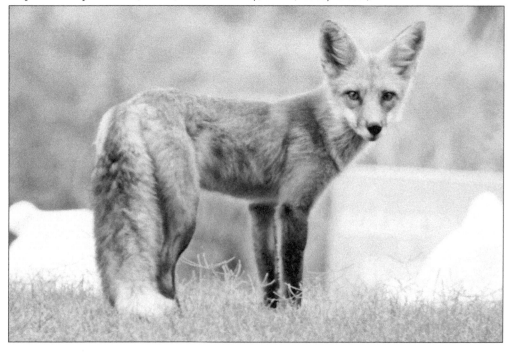

A stand of black locust trees in North Plat acts as a border between the Salt Lake City Cemetery and a smaller religious cemetery that abuts it. These deciduous trees grow from 30 to 50 feet tall and produce fragrant white flowers that tend to bloom around late May and attract bees. This photograph of a black locust tree in bloom was taken over Memorial Day weekend in 2014. (SLC Cemetery.)

One of the more unique tree species in the Salt Lake City Cemetery is the *Liriodendron* or tulip tree. This is a deciduous tree in the magnolia family. The pretty tulip-like flowers typically bloom each year around Memorial Day, which is a busy time of family picnics, parties, and ceremonies in the cemetery. Several smaller *Liriodendron* trees have been planted throughout the cemetery and will eventually reach an impressive stature, between 60 and 90 feet tall with a trunk diameter of four to six feet. The *Liriodendron* is the state tree of Kentucky, Tennessee, and Indiana. The largest specimen of this tree in the cemetery can be found in Plat U by the corner of 445 North and 900 East. (SLC Cemetery.)

Kwanzan flowering cherry trees are amazingly colorful specimens planted on the west side of the sexton's office. It is truly a tree for all seasons, with bright pink blossoms in the spring and radiant fall color as well. (SLC Cemetery.)

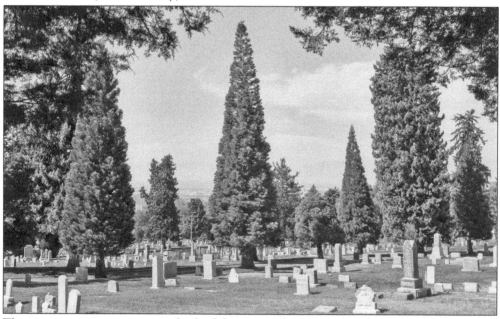

These giant sequoia trees were used as backdrops around event venues when Salt Lake City hosted the Winter Olympics in 2002. After the Olympic Games concluded, this grove of sequoias was replanted in Plat C along Grand Avenue, and other tree varieties were replanted within the cemetery and in city parks. Giant sequoias are considered the largest tree species in the world, and much older and larger giant sequoias can be found in the cemetery as well. (SLC Cemetery.)

Center Street in the Salt Lake City Cemetery, pictured above in 1917, continues to be shaded in summertime by these towering Norway maples. The Norway maple is native to Europe and has frequently been planted throughout urban areas in the United States. Just prior to its foliage blooming, small yellow flowers present in spring. Currently, this tree is prominently found along 1000 East in the cemetery, as shown below in 2017. (Below, SLC Cemetery.)

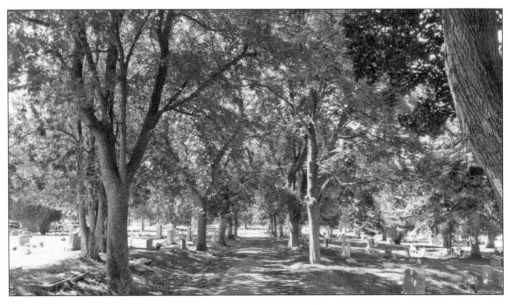

The smoke tree is a flowering, deciduous species native to Missouri and gets its name from fluffy hairs that grow on its flower clusters once they die. These hairs turn a smoky pink or purple color in the summer that creates a unique hazy effect on the tree. In the fall, this tree also develops a beautiful and vibrant coloring. These trees can be seen lining 380 North Street on the north side of Plat X. (SLC Cemetery.)

Also in Plat X, this green beech or European beech is one of the most beautiful trees in the Salt Lake City Cemetery thanks to its elegant spreading branches and leaves that turn rich copper in the autumn. This has been a popular ornamental shade tree in North America since European colonists brought it to the continent in the mid-1700s. It also produces edible beechnuts that ripen in the autumn. (SLC Cemetery.)

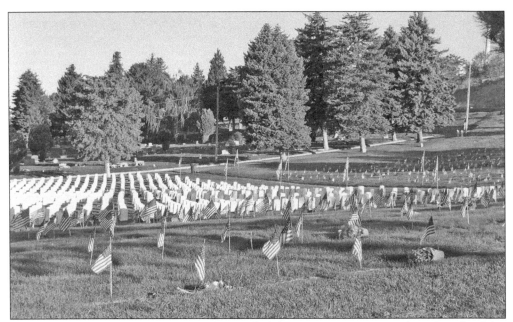

Norway spruces can be seen in the background of the veterans' section on the right side of this photograph, taken on Memorial Day weekend in 2013. The Norway spruce is known for its rapid growth; although it grows strong to a height of 40 to 60 feet in North America and has been widely planted here, it can grow to an impressive 150 feet in its native environment of Northern and Central Europe. (SLC Cemetery.)

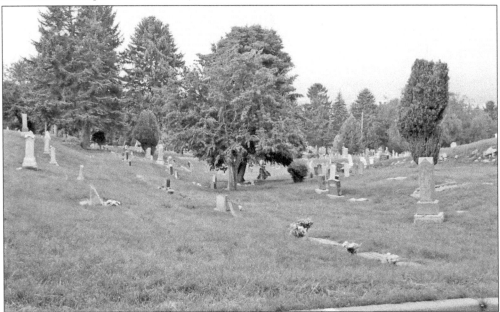

As visitors stroll through the cemetery, they can also see the English hawthorn tree, also known as "Paul's Scarlet," planted in several locations. This tree species features strikingly pink flowers in the spring, bright green leaves in the summer, and yellow color in autumn. Over the winter, the English hawthorn produces plump red berries, which are a great source of food for the birds and deer. (SLC Cemetery.)

The Persian ironwood tree grows 20 to 40 feet tall. In the Salt Lake City Cemetery, this tree features a variety of colors in the fall and uniquely multicolored bark during the winter, with patches of green, white, or tan that expose as the tree exfoliates. This species is found in several sites throughout the cemetery. The tree pictured here is at 1150 East and 380 North Streets. (SLC Cemetery.)

Beauty and romance may be the first things many people associate with the gleaming white paper birch. But this symbol of New England and state tree of New Hampshire has earned its place in history as a continuously useful tree that has served North Americans since the earliest days of human activity. Its graceful, arching branches give it an air of elegance as it watches over those who are buried beneath its shade. They are planted in several locations; the specimen pictured here is in Plat U. (SLC Cemetery.)

Three

PIONEERS

The history of Utah is defined by the Salt Lake Valley's initial settlement by pioneers belonging to The Church of Jesus Christ of Latter-day Saints. These Mormon pioneers traveled westward from Illinois to escape religious persecution and build a prosperous society of their own. Upon arrival in 1847, these determined individuals immediately set to work in developing the Salt Lake Valley and beyond with rapid success. Pioneer settlement is an honored and celebrated epoch within Salt Lake City and throughout the Intermountain West. Those pioneers who died on their westward crossing were often buried alongside the trail in makeshift graves, so it was important for many to have a dedicated site to remember lost loved ones. While all of the pioneers featured in this chapter shared the challenging experience of journeying across the American plains and building a life in a new place, and all were adherents to the Mormon faith, they walked a wide variety of paths in life and left diverse legacies after death. Pioneer-era migration officially ended with the completion of the transcontinental railroad. Through various genealogical projects, modern-day groups have identified many pioneer graves throughout the Salt Lake City Cemetery and have placed commemorative placards on their monuments.

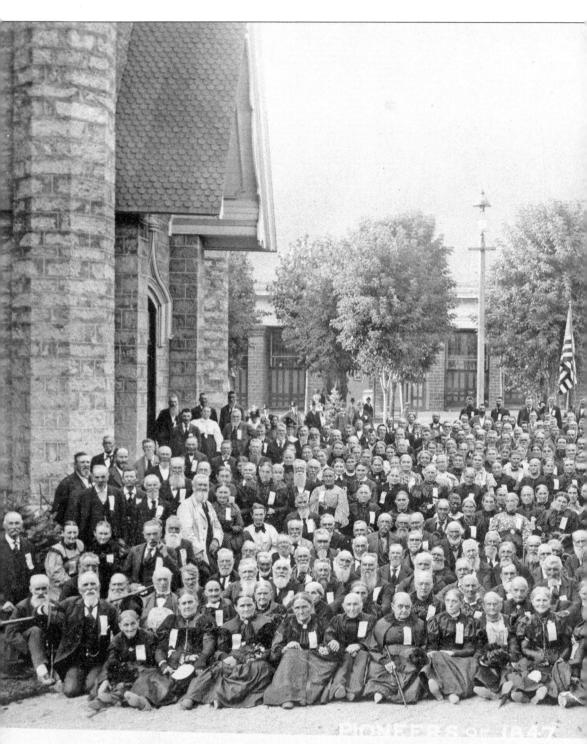

THE VETERAN PIONEERS OF 1847.

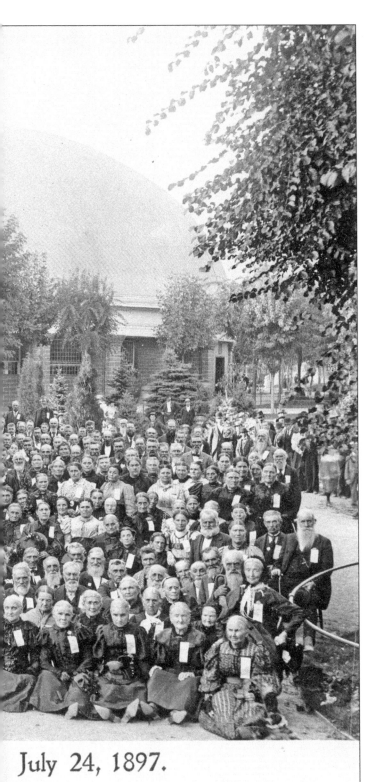

July 24, 1897.

H.

In 1897, fifty years after the Mormon pioneers first arrived in the Salt Lake Valley, a jubilee was held to honor the surviving pioneers, who are pictured here on Temple Square. Identification of the 250-plus surviving pioneers in this photograph is ongoing, but some of the known attendees are interred in the Salt Lake City Cemetery, including Jane Manning James, John H. Woodbury, G.W. Baker, and Mary Isabella Hales Horne. This four-day event drew people from across the state and the region to its many festivities. (DUP.)

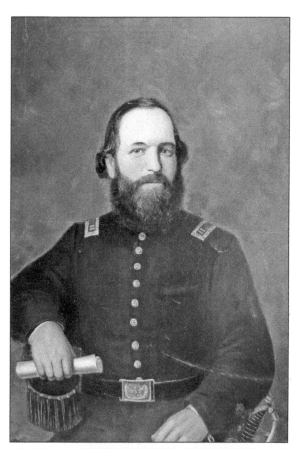

Most noted for his leadership and as the namesake of the fifth pioneer handcart company, Edward R. Martin (Plat F-2-8-3-E) was interred at the Salt Lake City Cemetery upon his death in August 1882. Visitors to his gravesite will notice two different markers placed back-to-back. The first is a red sandstone marker that reads "At Rest." The second, a white marble headstone, notes his service as a sergeant in the Mormon Battalion during the Mexican-American War. (Left, DUP; below, SLC Cemetery.)

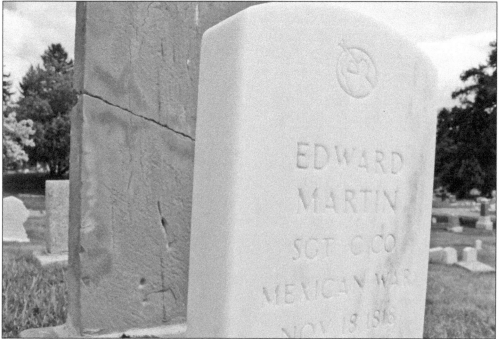

Edward Hunter (Plat C-10-10-4-W) was the longest-serving presiding bishop in the history of the church, serving from 1851 until his death in 1883. While bishop, he oversaw pioneer efforts to settle the Salt Lake Valley and had the local homestead community of Hunter named after him. As head of the church's Aaronic priesthood, Hunter laid the southwest cornerstone of the Salt Lake Temple on April 6, 1853. (Fox.)

After her husband, Hyrum Smith, died, Mary Fielding Smith (Plat B-15-12-4-W) set out west with fellow Mormon pioneers. She was advised against the challenging journey by a pioneer company captain, to which she reportedly replied, "I will beat you to the valley and ask for no help either." Smith was true to her word and reportedly arrived in the Salt Lake Valley one day prior to that captain. She died of pneumonia in September 1852; her burial in the Salt Lake City Cemetery is unconfirmed, but a memory stone bearing her name has been laid on the grounds.

Willard Richards (Plat H-10-11NROD) was an early member of the church, an apostle, and a witness to the martyrdom of Joseph and Hyrum Smith. A lifelong writer, Richards was church historian and recorder and the first editor in chief of the *Deseret News*. He also provided detailed writing about the life of Joseph Smith that was essential to the book *History of the Church of Jesus Christ of Latter-day Saints*.

Orson Pratt (Plat I-2-13-1-E) was the last living member of the original 1835 Quorum of the Twelve Apostles; he died in 1881. Pratt was a missionary in the northeastern United States, the British Isles, and Austria. He was also an accomplished scholar of philosophy, theology, mathematics, and astronomy, and gave educational lectures. Pratt served as the church historian and recorder and was the church's spokesman on the issue of polygamy. (Fox.)

A general authority and mission leader, Erastus Snow's presence (Plat Park-9-7-1-W, stone in C-6-11) in the East at the onset of the Civil War helped sway many church members to move to Utah. Snow was active in the Mormon colonization of Arizona, New Mexico, and Colorado. He is the namesake of Snow Canyon State Park, Snow College, and the town of Snowflake, Arizona, which he founded.

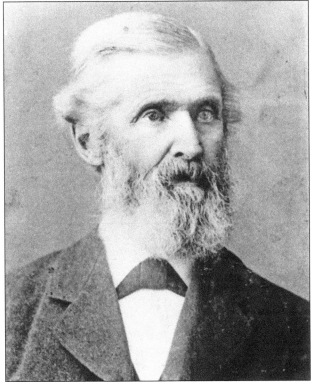

Truman O. Angell (Plat B-8-7-3-W) was the chief architect of the Mormon Tabernacle and the Salt Lake City Temple. Angell previously assisted in the construction of the Kirtland, Ohio, and Nauvoo, Illinois, temples. In Utah, Angell designed the St. George Temple, the Utah Territorial Statehouse in Fillmore, the John M. Whitaker House, the Logan Temple, and the Lion House and Beehive House, residences of Brigham Young and his family in Salt Lake City. Angell died in 1887, unfortunately before he could see the Salt Lake City Temple fully completed in 1893.

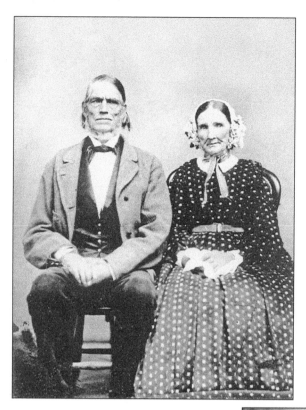

As a member of the first company to arrive in the Salt Lake Valley, Shadrach Roundy (Plat G-7-1-1-E) has ties to many important events in both church and state history. He also gained notoriety for his defense of church founder Joseph Smith during his final tumultuous years. One night, Roundy kept a group of angry men from gaining access to the Smith property with only his walking stick and calm but stern demeanor. He is pictured with his wife, Elizabeth Quimby. (DUP.)

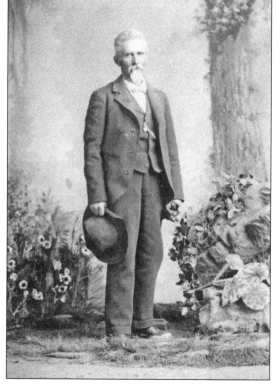

Despite being one of the original settlers of the western Salt Lake County community of Hunter, pioneer, homesteader, and Black Hawk War veteran Edward Rushton (Plat D-3-18-1-E) chose to be interred in the Salt Lake City Cemetery. This reunited him and his wife, Caroline, with their infant children who had preceded them in death. (SLC Cemetery.)

The first mayor of Salt Lake City was Jedediah Morgan Grant (Plat F-13-9-1-W), also known as "Brigham's Sledgehammer" for his impassioned sermons that inspired the Mormon Reformation of 1856. Grant participated in the presidential campaign of Joseph Smith and went on to serve as second counselor to Brigham Young. Morgan County and the town of Morgan, Utah, are named after him. His son, Heber J. Grant, grew up to become church president. (Fox.)

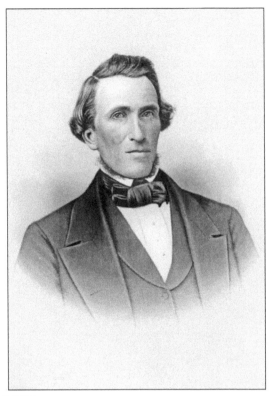

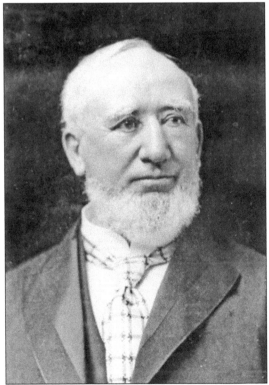

A four-term delegate for Utah Territory in the US Congress, George Q. Cannon (Plat B-11-171 NROD-1-E) also had a career in journalism and publishing: he directed the *Deseret News*, published a youth magazine, and founded the weekly *Western Standard*. He was first counselor to four church presidents, beginning with Brigham Young, and president of the church's California, Oregon, Eastern states, and Europe missions.

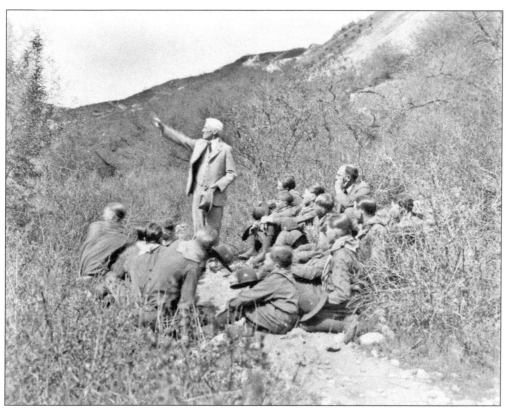

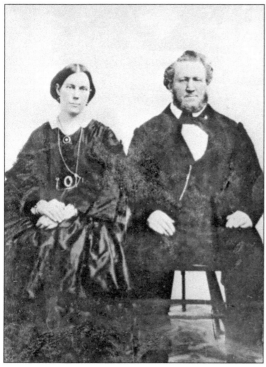

Anthony W. Ivins (Plat C-5-17-1-N2RDWY) was a member of the initial settling party for St. George, Utah, and held a leading role in the exploration of future Mormon colonies in New Mexico and Arizona. He was stake president of the first Mormon stake in Mexico, in Colonia Juarez, Chihuahua. He is pictured here in 1927 leading a group of Boy Scouts over the Mormon Trail, which traces the westward route of Mormon pioneers.

Amelia Folsom Young (Plat Park-13-11-1EN2) was the 25th wife of Brigham Young, with whom she is pictured here, and was reputed to be his favorite wife. After marrying in 1863, Amelia briefly oversaw the Gardo House, a residence for visiting dignitaries to Utah. The Gardo House was nicknamed "Amelia's Palace" because she lived there alone, apart from Young's other wives. She went on to remarry and participate in the women's suffrage movement.

William Wines Phelps (Plat H-3-10NROD-2-E) printed the first Latter-day Saint hymnal, including several hymns he wrote that became classics. Phelps oscillated between allegiance to the Latter-day Saint movement and struggles with its leadership; he was excommunicated three times and contributed to Joseph Smith's arrest by testifying against him, but he also served on the Council of Fifty, the Utah territorial legislature, and the University of Deseret's board of regents after coming to Utah with the Mormon pioneers. (DUP.)

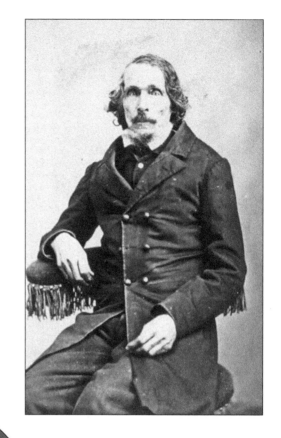

Born in a pioneer wagon, Anna "Annie" Maria Ballantyne Hyde (Plat N-5-1-2-E) was the founder and first president of the Daughters of Utah Pioneers. This volunteer-driven organization is still operating in the 21st century and preserves historic landmarks, educates about pioneer history, and operates the Pioneer Memorial Museum, located next to the state capitol. From 1901 until her death in 1909, Hyde also served as the first counselor to Relief Society president Bathsheba W. Smith. (DUP.)

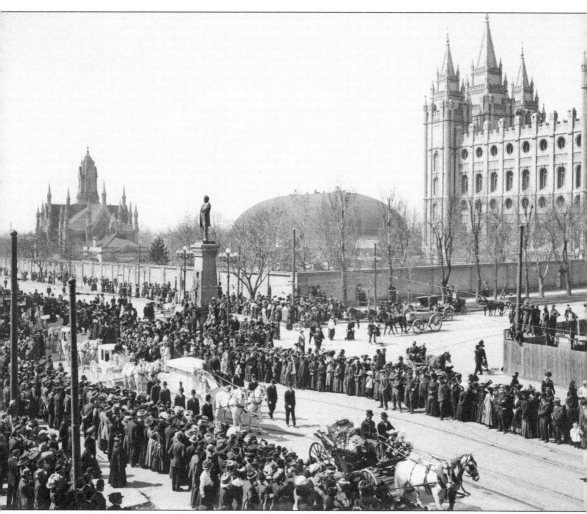

The death of a Latter-day Saint leader has always caused a big stir in Salt Lake City, the religion's hub. In 1910, the death of John R. Winder (Plat D-5-15-1-E), a pioneer, drew crowds to line up outside Temple Square as horse-drawn carriages drove to his funeral in the Salt Lake City Cemetery. Winder was first counselor to Joseph F. Smith and oversaw the completion of the Salt Lake Temple. He founded Winder Dairy, which is still in operation in 2018.

Four

PRESIDENTS OF THE CHURCH OF JESUS CHRIST OF LATTER-DAY SAINTS

Twelve presidents of The Church of Jesus Christ of Latter-day Saints are currently buried in the Salt Lake City Cemetery, and their graves often attract visiting school and church groups, historians, and individuals who remember the impact of a president's leadership on their religion and wish to pay their respects. The funerals for these leaders are major events in the cemetery, resulting in significant set-up, large crowds of mourners, press coverage, and security details. Readers will note that Brigham Young is not buried in the Salt Lake City Cemetery, as is often mistakenly assumed; this Utah leader and the church's second prophet is instead buried in a small area on his former estate in downtown Salt Lake City. Church presidents Lorenzo Snow, buried in Brigham City, Utah, and Ezra Taft Benson, buried in Whitney, Idaho, are also not included in this section. Of course, the religion's founder and first president, Joseph Smith Jr., is buried in Nauvoo, Illinois, where he died. The information provided about religious leaders in this chapter is summary and brief but aims to highlight each church president's role in his community, the evolution of the faith, and Utah history.

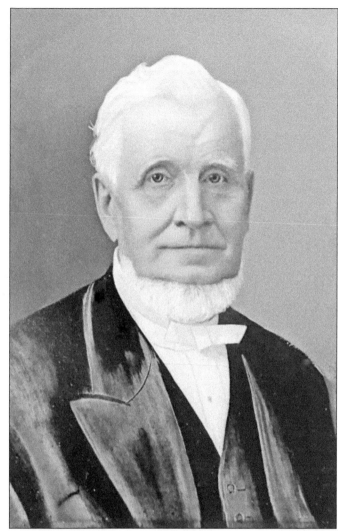

John Taylor (Plat F-11-9-2-E) immigrated to Canada from England and then to the United States with his wife, Lenora, to join the Latter-day Saint movement in Kirtland, Ohio. Taylor became a prominent member of the early church and grew close to Joseph Smith, whom he was with in the Carthage, Illinois, jail on the night Smith was killed. Taylor became church president in Utah in 1880, following the death of Brigham Young. He led the church through one of its most challenging periods, when the US government outlawed polygamy, which was permitted by the church at the time. Fearing arrest, he retreated from public view in 1885 and continued to lead the church as president in hiding until his death. Taylor died in Kaysville, Utah, in 1887 and is buried in the Salt Lake City Cemetery. Below is a stereoscope view of Taylor's portrait at his funeral. (Left, Fox; below, DUP.)

As the fourth president of The Church of Jesus Christ of Latter-day Saints, Wilford Woodruff's death drew a large crowd of mourners to the Salt Lake City Tabernacle, where funeral services were held. Woodruff (Plat C-6-10-1-E) passed away in San Francisco after a brief illness. During his lifetime and leadership, the church increased its membership significantly and publicly disavowed the practice of polygamy. Woodruff was also the first president of the St. George Temple, the first temple where endowment ordinances were performed for the dead, as well as a successful farmer and local and territorial politician. He was interred in the Salt Lake City Cemetery on September 8, 1898. (Right, Fox.)

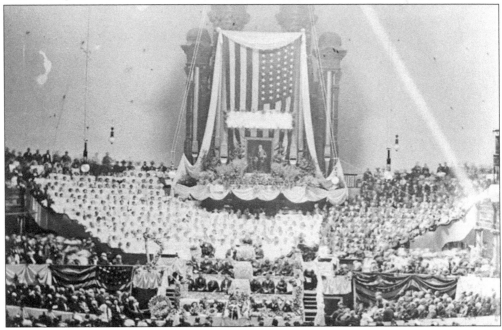

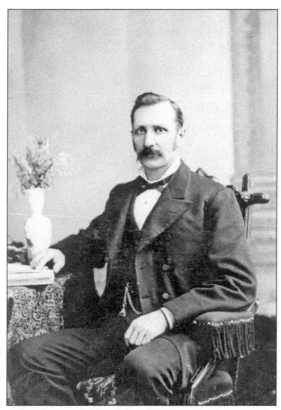

Joseph F. Smith (Plat Park-14-12-2-E) was president of the church from 1901 until his death in 1918, a member of Utah's territorial legislature from 1865 to 1874, and a leader in developing key sites in church history for visitation and preservation for future generations. The son of Hyrum Smith and nephew of founder Joseph Smith, Joseph F. Smith traveled to Utah Territory with his mother, Mary Fielding Smith, in 1848. His son Joseph Fielding became church president in 1970. The photograph below shows Joseph F. Smith on the left with Junius F. Wells, a champion of historic monuments, in front of the Hyrum Smith Monument at the Salt Lake City Cemetery. (Below, courtesy of the Church History Library, The Church of Jesus Christ of Latter-day Saints.)

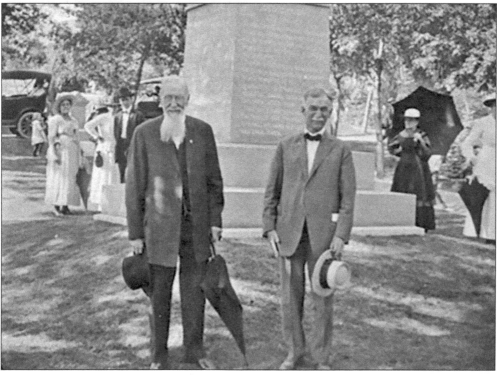

The first church president born in Utah was Heber J. Grant (Plat N-2-1-2-E). Born in 1856 as the son of Salt Lake City's first mayor, Jedediah Morgan Grant, Heber Grant witnessed and participated in an era of massive change in Utah and his religion. He led the church through two world wars and the Great Depression, which spurred him to establish the first church welfare program. Grant established the first Mormon stakes outside of the Intermountain West and served missions in Mexico and Japan. Notably, he was the last church president who practiced polygamy, although he did push for church members to renounce the practice. He was the longest-serving president in the church's history, holding the role for nearly 27 years. Grant was also a successful businessman who helped develop the Avenues neighborhood of Salt Lake City, where the cemetery is located. He died of heart failure in Salt Lake City in 1945 at the age of 88. His funeral is pictured below.

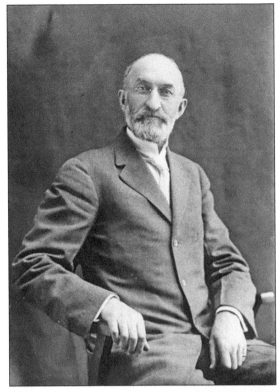

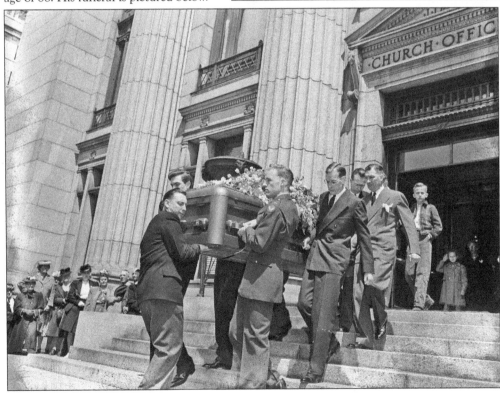

George Albert Smith (Plat I-5-15-1-S2RDWY) was president of the church from 1945 until his death in 1951. Pictured below strolling through the woods, Smith interacted with Utah natural lands in both his professional career and church service. As a young man, he worked for the Federal Land Office for Utah, and he strongly supported the Boy Scouts and promoted Scouting for Latter-day Saint boys as a church leader. He was also an international traveler. Smith was the British and European mission president and the first church president to visit Mexico while in office. Notably, Smith organized welfare assistance to Europe on behalf of the church following World War II. He died on his 81st birthday.

David O. McKay (Plat West-3-79-1-W) was the ninth president of The Church of Jesus Christ of Latter-day Saints, a position he served in for nearly 20 years. His presidential term, combined with decades of other church roles, make him the longest actively serving general authority, with a total of 64 years. As church president, McKay met with and counseled several world leaders, including then-candidate John F. Kennedy at the church headquarters on September 23, 1960. The Brigham Young University and Weber State University schools of education are both named after McKay in recognition of his work on education, especially religious education, in Utah.

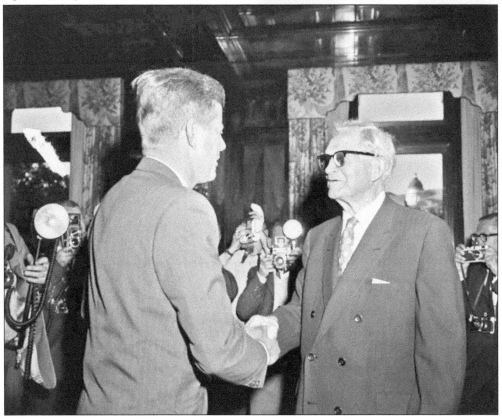

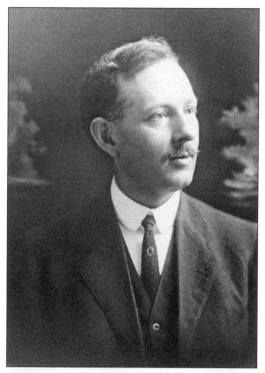

In almost 75 years of church service, Joseph Fielding Smith (Plat Park-14-14-1-E) held the roles of missionary, church historian, member of the Quorum of the Twelve Apostles, president of the Genealogical Society of Utah, and president of the Salt Lake Temple, as well as church president from 1970 to 1972. He was the son of Joseph F. Smith and grandson of Hyrum Smith. (Left, Fox.)

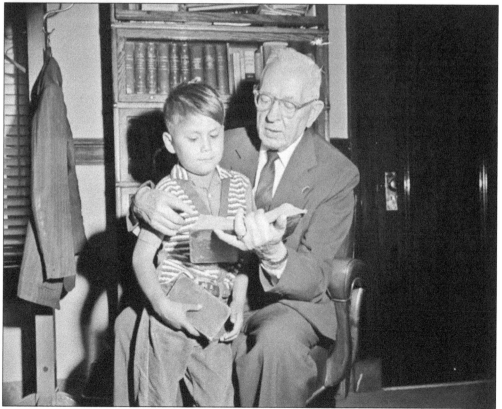

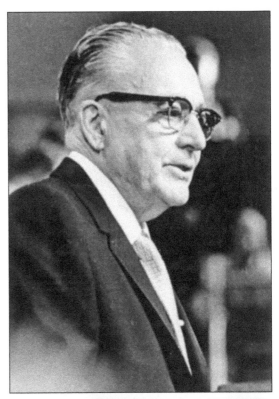

The 11th president of the church, Harold B. Lee (Plat West-6-76-1-E), was widely known for his charitable relief work for the needy during the Great Depression, which laid the groundwork for the church's current welfare system. Although Lee only served as church president for 18 months from 1972 to 1973, his impact as president endures through the organizational changes he instituted that shaped the church's modern structure and allowed for its worldwide expansion. He is pictured below with US vice president Spiro T. Agnew (far right).

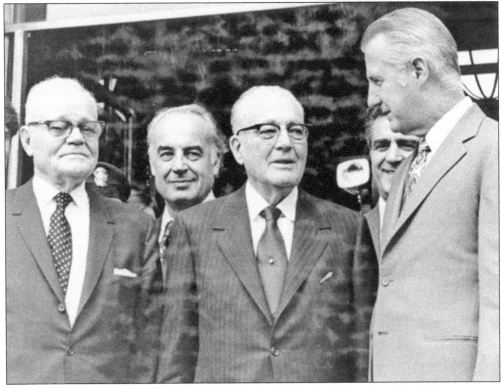

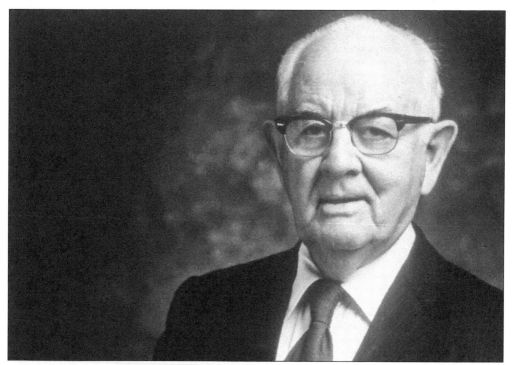

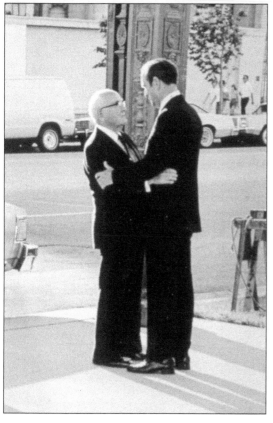

Spencer W. Kimball became president of the church in December 1973, following the sudden death of Harold B. Lee. Kimball is well known for his leadership in the 1978 policy change that removed racial restrictions to the priesthood. At left, Kimball is seen on the streets of Salt Lake City with his renowned heart surgeon and the most recent church president, Russell M. Nelson. (Above, Marriott Library; left, courtesy of the Nelson family.)

Howard W. Hunter (Plat West-12-36-3-E) had a successful law career and served the church as a member and president of the Quorum of the Twelve Apostles from 1959 to 1994, at which time he became church president for nine months prior to his death. As an apostle, he led the establishment of the Brigham Young University Jerusalem Center, was chairman of the board of the Polynesian Cultural Center, and was president of the Genealogical Society of Utah. The photograph below shows Hunter on the right, inspecting the Genealogical Society of Utah's IBM magnetic tape units.

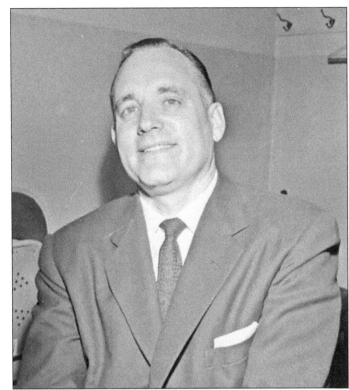

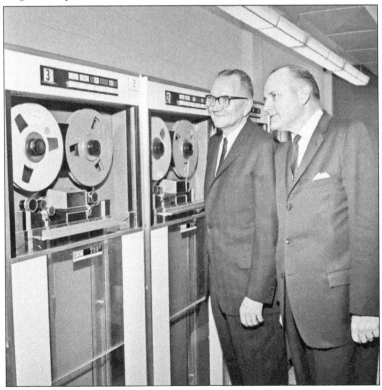

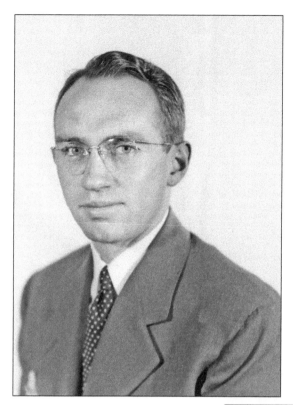

When Gordon B. Hinckley (Plat West-3-178-2-W) became president of the church, there were only 47 temples in operation, but by the time of his death, that figure had risen to 124 in all corners of the globe. In addition to spearheading this intensive period of temple construction, Hinckley was a bestselling author and a recipient of the Presidential Medal of Freedom, 10 honorary doctorates, and other educational awards. The Gordon B. Hinckley Alumni and Visitors Center at Brigham Young University was named in his honor. Hinckley died in 2008; his funeral services drew thousands of well-wishers, many of whom lined N Street from the downtown church conference center all the way to the Salt Lake City Cemetery, waving walking canes in farewell as Hinckley was known to do in life. Hinckley was laid to rest in a private ceremony alongside his wife, Marjorie Pay Hinckley. (Fox.)

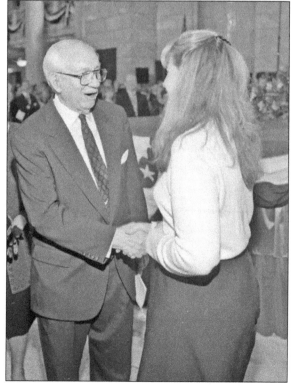

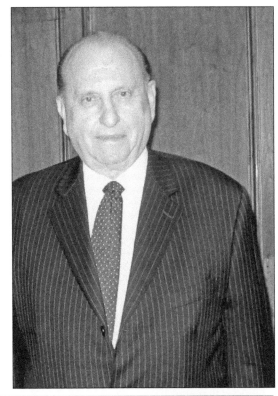

Thomas S. Monson (Plat A-15-10-2-W), a religious leader and businessman, is the most recent president of The Church of Jesus Christ of Latter-day Saints buried in the Salt Lake City Cemetery. As president of his church, Monson was notable for lowering the minimum age for missionaries, which greatly expanded their participation in missions around the world, and for dealing with controversy surrounding the church by publishing official essays on challenging topics and allowing greater transparency about church history. He is seen below conversing with Gertrude and Jack Condie in their home. Monson passed away in January 2018. (Right, Fox; below, courtesy of the Condie family.)

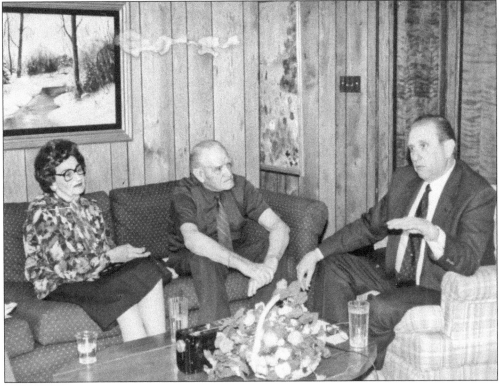

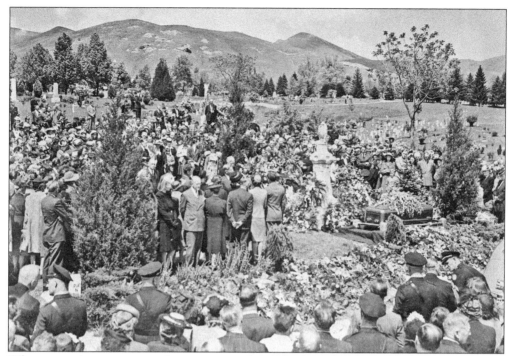

When a prominent person in the community dies and is buried in the Salt Lake City Cemetery, extensive set-up is needed to facilitate a larger crowd of mourners, foreign dignitaries, the press, photographers, and in the 21st century, videographers. Above, the funeral of church president Heber J. Grant is shown with its large crowds of mourners and floral displays. The funeral of church president Gordon B. Hinckley occurred in January 2008. In recent times, staging structures and video equipment are incorporated into these prominent burials, as seen below at Hinckley's ceremony. (Below, SLC Cemetery.)

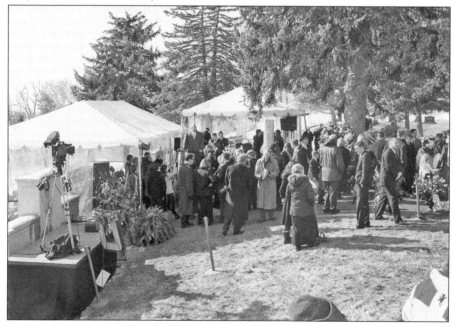

Five

LATTER-DAY SAINT LEADERS AND INFLUENCERS

While the Salt Lake City Cemetery is nondenominational, it is representative of Utah's Mormon history and the impact of the Mormon culture on the region, with a great number of Latter-day Saint leaders and influencers buried within. All of the individuals highlighted in this chapter made significant contributions to their faith community. Some are relatives and descendants of the church's founder, Joseph Smith, and numerous others preached their faith internationally, established key religious and community institutions, participated in politics, composed beloved hymns, and more. The majority of these individuals served in the role of a general authority, meaning that they held an important ecclesiastical leadership position at the highest level of church organization. All the people in this chapter lived fascinating lives and had a significant impact on the religion as well as, frequently, on Utah history with involvement in politics, the arts, activist causes, business, and more in addition to their church service.

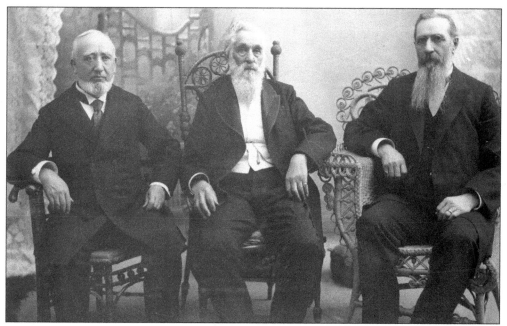

The highest level of leadership in The Church of Jesus Christ of Latter-day Saints is a group of men known as apostles. The most senior of them is the president of the church, who, along with two other apostles, constitute the First Presidency of the church. Here, Pres. Lorenzo Snow is at center with First Counselor George Cannon to the left and Second Counselor Joseph F. Smith to the right. (DUP.)

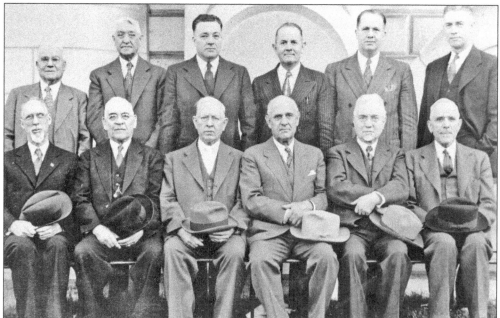

Pictured here in 1930 is the Quorum of the Twelve Apostles outside of the Salt Lake City Temple. Nine of these religious leaders are buried in the Salt Lake City Cemetery: George Albert Smith, George F. Richards, Joseph Fielding Smith, John A. Widstoe, Charles A. Callis, Albert E. Bowen, Harold B. Lee, Spencer W. Kimball, and Mark E. Petersen.

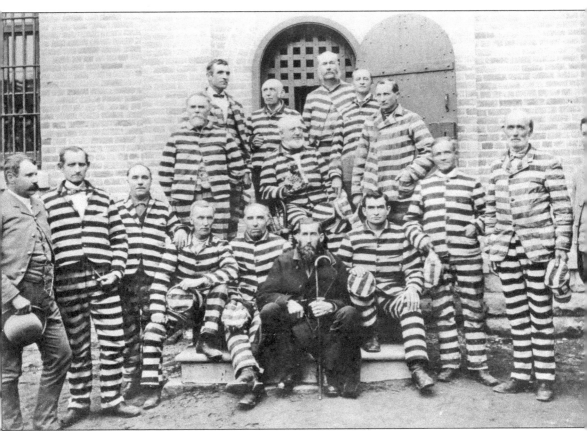

Polygamy, or plural marriage, was accepted—and widely practiced—among Latter-day Saints until 1890, when it was disavowed in a manifesto by church president Wilford Woodruff. The federal government imprisoned many top church leaders for marrying multiple wives. The church leaders pictured here were held for charges related to polygamy at the Sugarhouse Penitentiary in Salt Lake City in the late 1880s. The graves of several of them can be found in the Salt Lake City Cemetery, including George Q. Cannon (seated at center holding flowers), James Campbell Hamilton, James A. Bywater, Elijah Spencer Sheets, Elijah F. Sheets, Thomas Harper, and William Henry Foster.

J. Golden Kimball (Plat N-3-6-2-E) achieved folklore status as one of the most quoted and beloved leaders in church history, noted for using humor, candor, and unusually colorful language in his sermons. Kimball is cited with observations such as "I may not always walk the straight and narrow, but I sure in hell try to cross it as often as I can." For 36 years, Kimball served as a general authority in the church. In 1938, Kimball was tragically killed in a car accident in Nevada at the age of 85.

Hugh W. Dougall (Plat P-9-8-5-E) was a hymn writer, the music supervisor for public schools in Utah, and a member of the Salt Lake Opera Company. He was a grandson of Brigham Young.

Albert E. Bowen (Plat West-3-153-1-W) was ordained to the Quorum of the Twelve Apostles by church president Heber J. Grant in 1937 and served in that role until his death on July 15, 1953. Bowen was also a practicing lawyer in Utah; president of the Sunday School Union for the Cache Stake in Logan, Utah; and superintendent of the Young Men's Mutual Improvement Association. Bowen is pictured with his second wife, Emma Lucy Gates Bowen, a noted singer and a granddaughter of Brigham Young. He died in 1953.

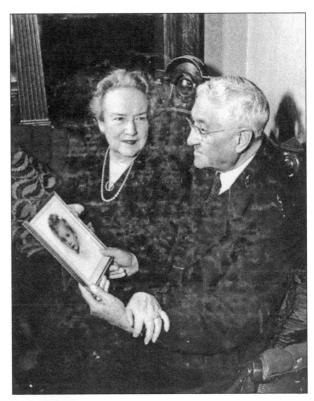

Melvin J. Ballard (Plat Park-34-10-2-W) was a notable missionary in the early years of missions in South America, a contributing member of the Church Music Committee who helped create an updated hymnal, and the general chairman of the church's Welfare Committee. He was born in 1873 in Logan, Utah Territory, and was buried in the Salt Lake City Cemetery in 1939. (SLC Cemetery.)

Buried in the Salt Lake City Cemetery in 1975, Hugh B. Brown (Plat West-14-94-3-W) led a varied and fascinating life that included military service, leadership in the church's Quorum of the Twelve Apostles and First Presidency, and work as an attorney, farmer, cowboy, businessman, and professor of religion at Brigham Young University. He is pictured second from left at the dedication of the Eagle Gate in downtown Salt Lake City, which marks the site of Brigham Young's original family estate in the Salt Lake Valley.

Born in Grantsville, Utah, in 1871 into a farming family, J. Reuben Clark (Plat West-3-120-3-E) showed early academic promise and was encouraged by his family to pursue his education as much as possible. This encouragement resulted in a prominent career in law and diplomacy with the US State Department. Clark worked as undersecretary of state and US ambassador to Mexico. The J. Reuben Clark Law Society and the J. Reuben Clark Law School at Brigham Young University are named in his honor.

Matthew Cowley (Plat N-2-16-1-E) traveled to New Zealand as a young man on a church mission and fell in love with the Maori people and Pacific Island cultures. Following his return to the United States, he obtained bachelor's and law degrees, and assisted Sen. Reed Smoot in Washington, DC. Cowley became the New Zealand mission president and took his young family abroad with him. He later served as president of the Pacific church missions while a member of the Quorum of the Twelve Apostles. He is the namesake of the Matthew Cowley Pacific Church History Centre, which includes the Pacific Church History Library and Pacific Church History Museum in Hamilton, New Zealand. (Fox.)

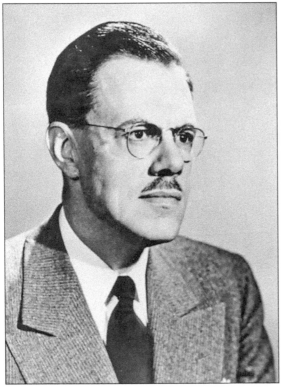

In addition to his membership in the Quorum of the Twelve Apostles from 1953 to 1971, Richard L. Evans (Plat West-11-171-1BTW2-E) is well known for the Mormon Tabernacle Choir radio broadcast *Music and the Spoken Word*. Every week for 41 years, Evans wrote, produced, and announced the popular show. From 1966 to 1967, Evans was also the president of Rotary International. He passed away in 1971 at the age of 65 and was buried in the Salt Lake City Cemetery. His gravestone features the appropriate epitaph "May peace be with you. This day . . . and always," his signature conclusion to the *Spoken Word* broadcasts.

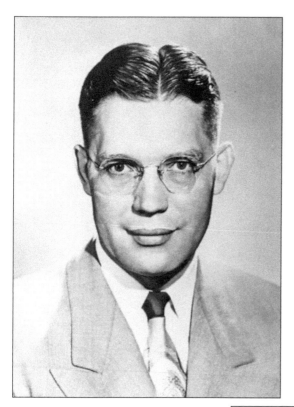

A member of the Quorum of the Twelve Apostles and a decorated Army veteran who contributed to military intelligence from Fort Douglas in Utah during World War II, Bruce R. McConkie (Plat West-15-57-4-W) died on April 19, 1985, at the age of 69. McConkie was an author of many books and articles and crafted chapter headings in church-published scriptures. He was married to Amelia Smith, the daughter of church president Joseph Fielding Smith, and together they had nine children.

Charles W. Penrose (Plat P-2-7-3-E) was a second counselor in the First Presidency for Pres. Joseph F. Smith and Pres. Heber J. Grant. Upon permanently immigrating to Utah following missions in his native England, Penrose settled in Ogden and became the editor of the *Deseret News*. He also lent his writing abilities to missionary tracts and the lyrics to several notable hymns, such as "Beautiful Zion for Me," "God of Our Fathers," "We Come Unto Thee," "O Ye Mountains High," "School Thy Feelings," and "Up, Awake, Ye Defenders of Zion."

LeGrand Richards (Plat Q-16-5-3-W) was a member of the Quorum of the Twelve Apostles, the seventh presiding bishop of the church, a widely active missionary, and the author of *A Marvelous Work and Wonder*. Both his father, William Richards, and grandfather were members of the Quorum of the Twelve Apostles. He was buried in the Salt Lake City Cemetery in 1983.

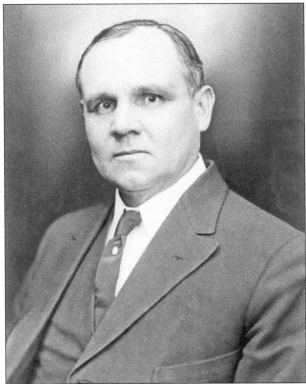

James E. Talmage (Plat C-CA-2-1-E) was an English chemist, geologist, and religious leader who served as a member of the Quorum of the Twelve Apostles from 1911 until his death. Talmage is remembered for writing several well-known religious books, including *The Articles of Faith*, *The Great Apostasy*, *The House of the Lord*, and *Jesus the Christ*.

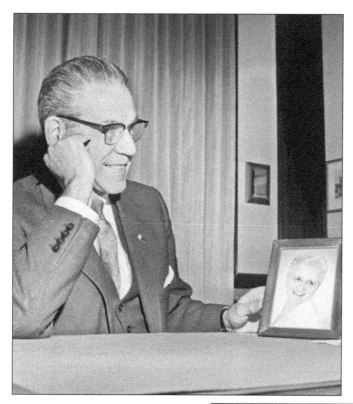

Nathan Eldon Tanner (Plat I-14-5-1-E) grew up in Alberta, Canada, and lived and worked there throughout his adult life, although he traveled internationally on church business. He served as counselor to four church presidents: David O. McKay, Joseph Fielding Smith, Harold B. Lee, and Spencer W. Kimball. Tanner died while serving as a member of the First Presidency on November 27, 1982, and as Gordon B. Hinckley was already an extra counselor in the First Presidency, no new apostles were called as a result of his passing.

Charles A. Callis (Plat West-3-96-1-E) served in the first Utah state legislature as an elected representative to the Utah House of Representatives. He was also active in the church as a missionary, mission president, and member of the Quorum of the Twelve Apostles. Callis died of a heart attack in 1947. Although he was buried in the Salt Lake City Cemetery, funeral services were also held in Jacksonville, Florida, where he died and was known for organizing the first Mormon stake in the southern United States.

Rudger Clawson (Plat Park-1-3-5-W) was a member of the Quorum of the Twelve Apostles. Notably, he faced severe anti-Mormon sentiment as a missionary in Georgia and witnessed his companion Joseph Standing's murder at the hands of a mob. Later, as a general authority, Clawson was the first member of the Quorum of the Twelve Apostles to be convicted for polygamy under the Edmunds Act; Clawson served almost three and a half years in prison for marrying multiple wives. He died in 1943.

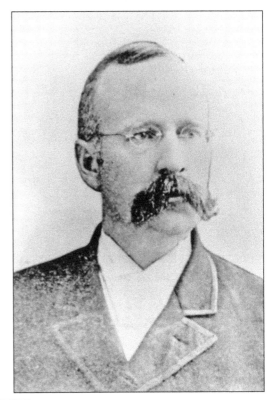

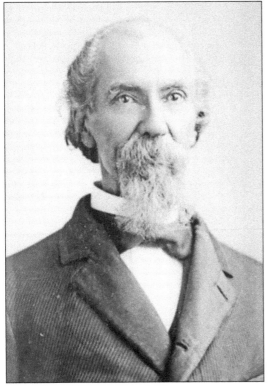

George Teasdale (Plat B-5-8-1-W) learned about the Latter-day Saint movement from a coworker in England, where he was born. He became active in the church in England and Scotland and later immigrated to Utah Territory with his wife in 1861, where he joined the Mormon Tabernacle Choir and served multiple domestic and international missions. In 1891, Teasdale was named president of the mission in Mexico. He died in 1907 at the age of 75.

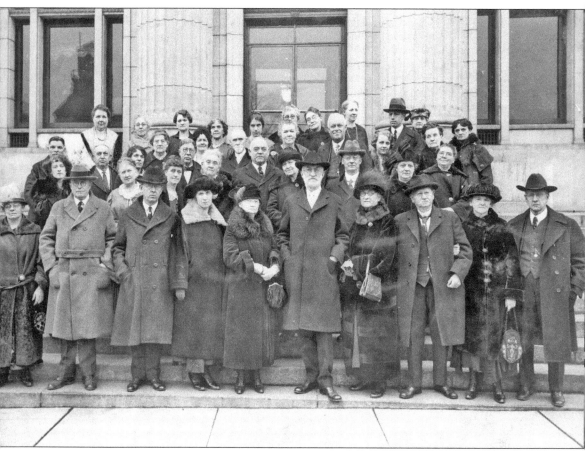

Genealogical research and work at the Salt Lake City Cemetery have had a historically close relationship. This December 15, 1923, photograph of the Genealogical Society of Utah was taken on the steps of the Church Office Building. The front row features the tall Pres. Heber J. Grant with Mrs. Grant.

Neal Maxwell (Plat West-12-100-4-E) was a general authority in the church and is most known for authoring approximately 30 books about religion and presiding over the organization of the church's first stake composed entirely of Africans in Aba, Nigeria, in 1988. Maxwell died after a long battle with leukemia and was buried in the Salt Lake City Cemetery in 2004. (Marriott Library.)

L. Tom Perry (Plat B-6-3-3-E) was a veteran of World War II, a businessman, and a member of the Quorum of the Twelve Apostles. His Marine Corps unit was among the first troops to occupy Japan. Elder Perry was preceded in death by his first wife, Virginia Lee, in 1974 and was survived by his second wife, Barbara Dayton, as indicated on their newer upright monument. (Courtesy of Brigham Young University Library.)

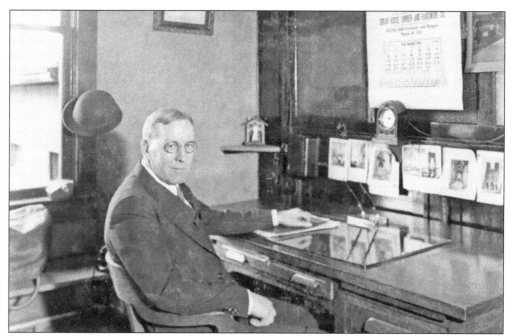

Ordained as a member of the Quorum of the Twelve Apostles at age 80 in 1954, George Q. Morris (Plat N-14-10-3-S2RDWY) was at that time the oldest person in church history to become an apostle. Prior to that, Morris was active in the Young Men's Mutual Improvement Association as first assistant to the organization's superintendent, Albert E. Bowen. Morris died in 1962 at the age of 88.

A member of the Quorum of the Twelve Apostles who had a particular impact on the church's business endeavors was Henry D. Moyle (Plat West-3-143-3-E). With a background in cattle, Moyle recognized the potential for cattle ranching in Florida and pushed the church to purchase 54,000 acres there in 1950 for a commercial ranch. That property has since grown to become the world's largest cattle ranch, with over 300,000 acres and, in 2018, an estimated worth of over $850 million.

Born in Farmington, Utah, and active in Tooele County throughout his life, George F. Richards (Plat Q-16-12-1-E) was a member of the Quorum of the Twelve Apostles from 1906 to his death in 1950 and the quorum's president from 1945 until his death. He also served as the acting presiding patriarch of the church from 1927 to 1942.

Eldred G. Smith (Plat Park-13-16-4-E) was the patriarch emeritus of the church and its oldest and longest-serving general authority at the time of his death in 2013 at age 106. Smith was named the presiding patriarch in 1947, a role tasked primarily with traveling to areas of the world without patriarchs and bestowing patriarchal blessings upon members of the faith there. Smith received the title of patriarch emeritus upon his release from the position of presiding patriarch; he is the only patriarch emeritus in church history to date. (Fox.)

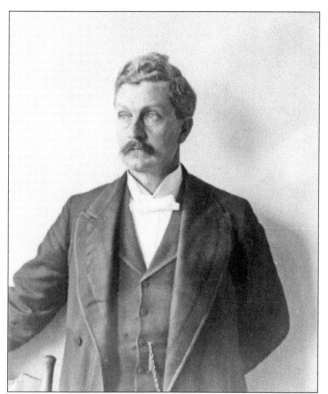

John W. Taylor (Plat N-4-14-3-E) was a general authority with the church at a time of major transition for the faith. Under extreme pressure from the US federal government to end the practice of plural marriage, church leaders issued the Second Manifesto in 1904, officially condemning polygamy. This shift in religious policy had a major impact on lifestyles and relationships and faced staunch opposition by many church members, including Taylor, whose refusal to discontinue his polygamous marriages to six wives led to his eventual excommunication from the church. (Marriott Library.)

In addition to his membership in the Quorum of the Twelve Apostles, a role that he held from 1906 until his death in 1931, Orson F. Whitney (Plat Q-8-11-1-E) was a writer, journalist, and composer of hymns such as "The Wintry Day, Descending to Its Close." Whitney, Idaho, is named in his honor.

Six

FASCINATING FIGURES

From gunslingers and outlaws to suffragists to business leaders and beyond, this chapter highlights a very wide variety of some of the most unique individuals who are buried in the Salt Lake City Cemetery. Their stories reflect historic moments in Utah and national history, international influences, societal progress, tragedy, larger-than-life drama, war, and so much more. Some of their stories have inspired and intrigued history buffs for generations. Others are less well-known but no less fascinating. Their intermingling throughout the cemetery shows how each and every grave has a captivating story waiting to be discovered and told, all of which could never be contained within a single volume.

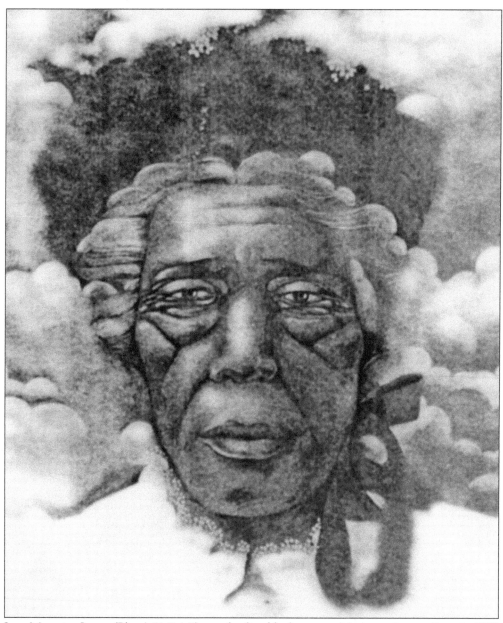

Jane Manning James (Plat A-11-8-4-E) was the first black woman Mormon pioneer. Born in 1822 to a free black family in Connecticut, she converted to the Church of Jesus Christ of Latter-day Saints as a teenager and traveled with her family to Nauvoo, Illinois, where Joseph Smith led the early Latter-day Saint community. James traveled over 800 miles to Nauvoo; in her autobiography, she wrote, "We walked until our shoes were worn out, and our feet became sore and cracked open and bled until you could see the whole print of our feet with blood on the ground." Along the way, the travelers also had to avoid authorities who threatened to detain and arrest them on account of their race. James was welcomed into Joseph Smith's home and the broader community and later continued westward with the Mormons to settle in Utah, where she took part in Relief Society activities, married Isaac James, and raised 10 children. Jane Manning James was noted by others, as well as in her tombstone's epigraph, as a devout, generous, and compassionate woman. (DUP.)

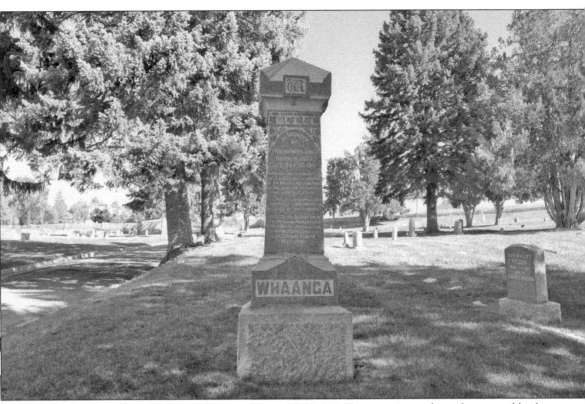

Maori chief Hirini Te Rito Whaanga (Plat S-36-5-1 & 2-E), a prominent sheep farmer and leader of the Ngati Kahungunu tribe in the Mahia district of northern Hawkes Bay, and his wife, Mere Mete Whaanga, were Latter-day Saint converts who were a driving force for the religion's spread in New Zealand. Baptized in 1884, the couple soon opened their home up as a gathering place for missionary work in the region. Ten years later, they immigrated to Utah to settle among the church community. In Utah, Mere attracted attention for her *moko*, blue facial tattoos traditional in Maori culture. After a challenging initial chapter in Kanab, Utah, Mere and Hirini Whaanga found a home in the Forest Dale Ward of Salt Lake City. Both eventually returned to their home country as popular and successful missionaries. Chief Whaanga died on October 17, 1905; Mere Mete lived until May 11, 1944, when she was buried with her husband. (SLC Cemetery.)

No.	Ward	Name of Deceased	To whom Related	Day	Month	Year	Town	County	State or N.
1446	13	Snow Erastus	Son of Wm & Jane Maria	2	Oct	1855	G.S Lake		
1447	13	Shearer Mary	Wife of Daniel Shearer	11	May	1789		G.S Lake	Utah
1448	8	Dewey Ella Lucinda	Daugh of Benj & Susan Alzena	30	Mar	1860	G.S Lake		
1449	19	Gardner Isaac	at Solomon Angells no known	30				G.S Lake	Utah
1450		Haslam Jane	Wife of John Haslam	about		1802	Simpson		
1451		Peterson Jas Wm	Son of Chas John & Caroline	11	Mar	1862		Fife	Scotland
1452	16	Francis Lucy	Daugh of John & Ann	8	Dec	1828	South Witham	G.S Lake	Utah
1453		Tom a negro	Belonging to Bishop Smoot					Lincoln	England
1454		Weight Ann	Wife of Jas Weight			1791			
1455	14	Taylor Wm Thos.	Son of Thos & Elizabeth				G.S Lake		England
1456		Gardner Margaret	Wife of Robert Gardner	28	Apr	1775	Falkirk	G.S Lake	Peter
1457		Neff Martha Ann	" Amos H.					Stirling	Scotland
1458	14	Richards Joseph Wm	Son of Saml. W & MaryAnn	25	Jan	1856	G.S Lake		
1459		Lord						G.S Lake	
1460	15	Bolser Fredk. R.	Son of John & Emma						
1461	12								

A man owned as a slave by Abraham Smoot, a prominent religious and political leader and proponent of slavery, was buried in a pauper's grave (Plat B-4-Pauper-877) in the Salt Lake City Cemetery. The cemetery records list this individual as "Tom (a Negro);" his last name and personal details are unknown. Based on census records, it is likely that Tom was about 42 years old when he died. In Utah, enslavement of black and Native American people occurred legally until slavery was abolished with the end of the Civil War.

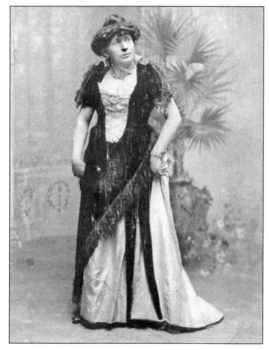

In the conservative 19th century and in Utah's religiously conventional environment, Brigham Morris Young's practice of dressing in women's clothing for singing performances was unique, albeit not unprecedented. Young (Plat U-4-7-1-E), known onstage as "Madame Patirini," possessed an excellent soprano voice and appeared in Utah night clubs. He was the 35th child of Brigham Young. (Courtesy of the Church History Library, The Church of Jesus Christ of Latter-day Saints.)

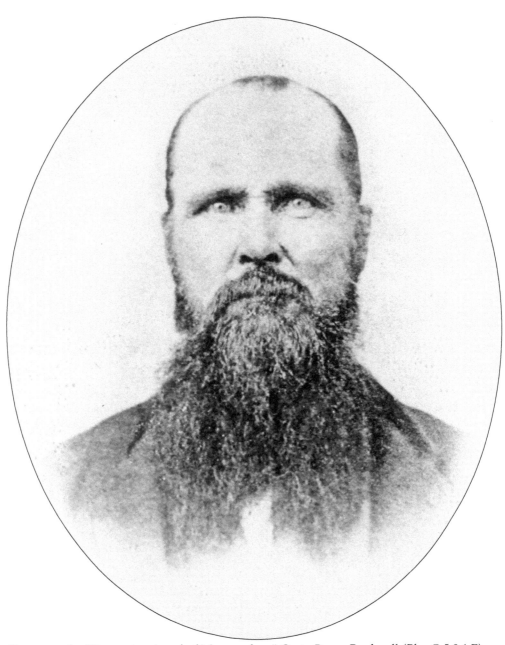

Known as the "Destroying Angel of Mormondom," Orrin Porter Rockwell (Plat C-5-9-1-E) was one of the very first people to join the church and was a pioneer, but is most remembered for being a widely feared gunslinging companion to church leaders Joseph Smith and Brigham Young. As a young man, Rockwell gathered and sold berries to raise funds for the initial publication of the Book of Mormon. Later, his precise aim with a shotgun earned him a reputation throughout the American West. Rockwell wore his hair very long, because Joseph Smith promised him that if he did not cut it, "no bullet or blade can harm thee." This rarely seen photograph of Rockwell with short hair was taken after he donated his blessed locks to make a wig for Joseph Smith's widowed sister-in-law, who had lost her hair due to typhoid fever. He died of natural causes on June 9, 1878. (DUP.)

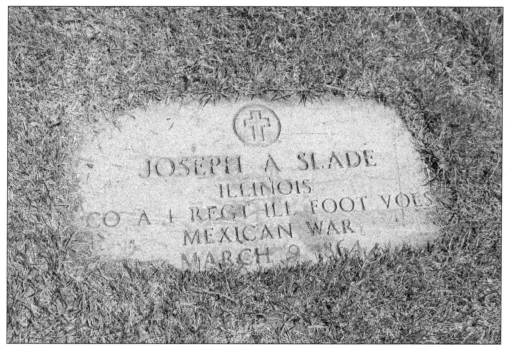

Joseph "Jack" Slade (Plat B-4-Pauper-116) personified the Western gunslinger archetype. He fought in the Mexican-American War and developed a regional reputation for drunk and violent conduct. Slade's body was preserved by his wife in an alcohol-filled, lead-lined coffin for the journey from Montana, where he was killed, to Salt Lake City. He was intended to be reinterred in his hometown of Carlyle, Illinois, but for unknown reasons, Slade was never moved, and the Salt Lake City Cemetery remains his final resting place. (SLC Cemetery.)

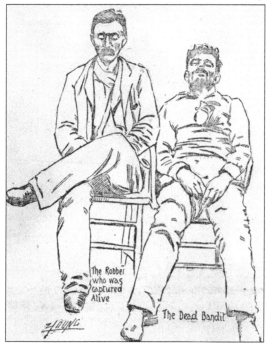

The Robber who was captured Alive

The Dead Bandit

Aspiring outlaw and cattle rustler Gunplay Maxwell (Plat K-12-16-3-E), also known as William H. Seaman, was reportedly rejected by prison associate Butch Cassidy from joining the famed "Wild Bunch." In attempting to replicate the exploits of that famous gang, Maxwell had an up-and-down career as a gunfighter and bandit. In the summer of 1909, Maxwell challenged Deputy Sheriff Edward Johnstone to a duel in Price, Utah. Maxwell only grazed Johnstone with the first shot, and the deputy returned fire. Two bullets knocked Maxwell to the ground, and a third ended the contest. Witnesses claim that Maxwell's last words were "Don't shoot again Johnstone, you have killed me." Gunplay Maxwell was buried in a potter's field section of the Salt Lake City Cemetery under the name of William Seaman in an unmarked grave.

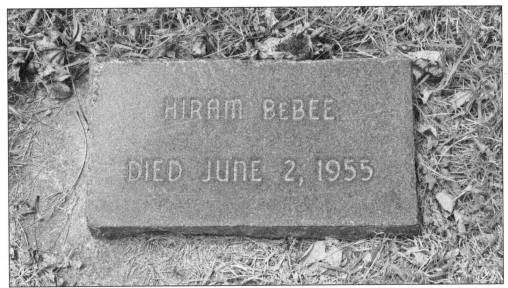

The "Sundance Kid" is an enduring American legend, and one to which Hiram Bebee (Plat North-2-30-2-E) pinned his name. Bebee was sentenced to life in Utah State Prison for killing a city marshal in 1945 and claimed to be the famous Sundance Kid, an outlaw who was a part of the Wild Bunch gang of bank robbers led by Butch Cassidy. Hiram Bebee was not, in fact, one and the same as Harry Alonzo Longabaugh—the real Sundance Kid—but his attempt to rename himself as such has given him a widely known reputation in the Salt Lake City Cemetery, where he was buried in 1955. (SLC Cemetery.)

Mark E. Petersen (Plat U-22-11-2-W) rose through the ranks of the *Deseret News*, starting as a paperboy and then working as an editor and general manager before becoming its parent company's president. In 40 years as a member of the Quorum of the Twelve Apostles, he employed his communication skills to direct public information programs and lead several committees. (SLC Cemetery.)

The downtown dining scene in Salt Lake City grew significantly thanks to the restaurateur John Williams (Plat U-36-12-1-W). As cofounder of Gastronomy Inc., Williams established 10 critically acclaimed restaurants, including New Yorker and Market Street Grill. He also helped found the Salt Lake City Downtown Alliance and led restoration projects for prominent historical buildings. In 2016, Williams was tragically murdered. (Courtesy of New Yorker.)

Lawrence Horne "Larry H." Miller (Plat U-27-12-4-W) was a Utah businessman and philanthropist who was most notably owner of the Utah Jazz basketball team. Miller became co-owner of the Jazz in 1985 and full owner in 1986 with a vision to boost the franchise within the community. Miller's business began as a single Toyota dealership in 1979 and grew into one of the largest privately owned family companies in the Intermountain West. His grave was designed to be visible downhill from the Miller home in the adjacent Avenues neighborhood. (Courtesy of the Miller family.)

As head of the Salt Lake City traffic squad, Lester Farnsworth Wire (Plat P-9-13-3-E) invented the world's first electric traffic signal in 1912. Prior to Wire's invention, traffic patrolmen had struggled to control chaotic traffic; growing numbers of automobiles jostled for the right of way with pedestrians, trolley cars, horses, and buggies, and accidents were common. The electric signal, with its now ubiquitous red and green lights, was at first viewed with derision and nicknamed "Wire's birdcage" and "Wire's pigeon house," but its functionality eventually gained it acceptance worldwide. Wire was unable to obtain a patent for his traffic light and never received any money for his invention. He died on April 14, 1958, at age 70.

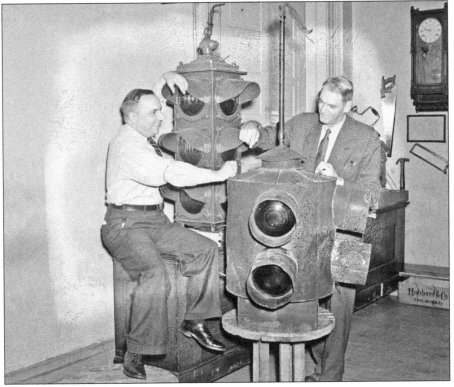

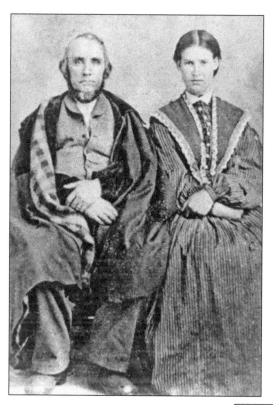

A clerk and scribe to Joseph Smith, William Clayton's best-known legacy is his composition of the beloved hymn "Come, Come, Ye Saints." He was also an early scribe for the church, a missionary in England, and the inventor of a prototype version of the odometer. This man of diverse interests and accomplishments passed away in 1879 and is buried in the Salt Lake City Cemetery. (Plat H-3-8-5-E).

A pioneer in medicine and women's rights, Romania Pratt Penrose (Plat Park-2-6-2-W) was the first licensed female doctor in Utah. After receiving her medical degree in 1877 from the Women's Medical College of Pennsylvania, Dr. Penrose returned to Salt Lake City and practiced at the Old Deseret Hospital.

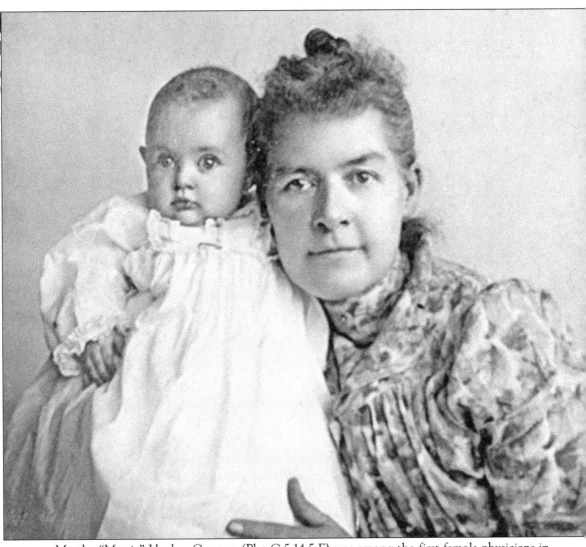

Martha "Mattie" Hughes Cannon (Plat C-5-14-5-E) was among the first female physicians in Utah, a suffragist, and the first woman state senator elected in the history of the United States. Despite legal challenges she faced as a member of a polygamous marriage, including exile abroad, Dr. Cannon sustained an active professional life and entered the Utah political arena. In her 1896 campaign for state senate, she notably ran as a Democrat against her own husband and won. Dr. Cannon served two terms as state senator and was instrumental in passing key sanitation laws and establishing the state Department of Health and the Utah State School for the Deaf, Dumb, and Blind. Martha Hughes Cannon died in Los Angeles, California, on July 10, 1932, and in 2018, the Utah state legislature approved a measure to honor her with a statue in the US Capitol's Statuary Hall in Washington, DC. The executive conference room in the Salt Lake City & County Building also bears her name, and a there is a statue of her in the courtyard of the state capitol. (Fox.)

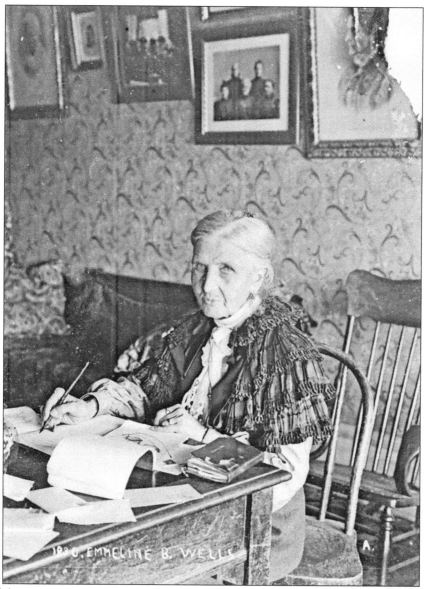

One of the most influential advocates for women's rights in Utah was Emmeline B. Wells (Plat H-3-9NROD-4-W). As the editor, owner, and publisher of the *Women's Exponent*, a popular newspaper for Latter-day Saint women, Wells put forth numerous articles promoting the legal, political, and religious rights of women. She befriended Susan B. Anthony at the 1879 convention of the National Woman Suffrage Association in Washington, DC, and worked with her to defend women's right to vote from the threat of repeal by the US Congress. Although federal legislation did take away women's suffrage in Utah, Wells persisted and successfully organized support for the inclusion of women's suffrage in the Utah constitution, which reinstated women's right to vote in 1895. At the age of 82, Wells became the fifth Relief Society president; under her leadership, the organization sold more than 200,000 bushels of desperately needed grain to the federal government during World War I. Pres. Woodrow Wilson and his wife personally visited Wells to thank her for her assistance. Emmeline B. Wells died in 1921. Her funeral was held in the Salt Lake City Tabernacle. (Fox.)

Ellis Reynolds Shipp (Plat I-16-9-2-W) was one of the first female doctors in Utah. She studied medicine at the Women's Medical College of Pennsylvania in Philadelphia. Undeterred by financial issues or pregnancy, she graduated in 1878 and returned to Utah to open a medical practice. The same year, Dr. Shipp also established her own school of obstetrics and nursing with the goal of educating more woman doctors.

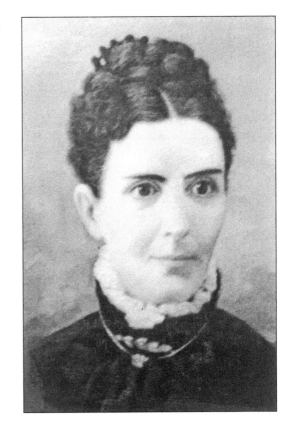

A prominent early figure in the church for work on behalf of women's equality and suffrage, Sarah Melissa Granger Kimball (Plat E-12-14-2-E) founded the Ladies' Society of Nauvoo, which grew into today's Relief Society. After moving to Salt Lake City, Kimball served as vice president of the Relief Society. (DUP.)

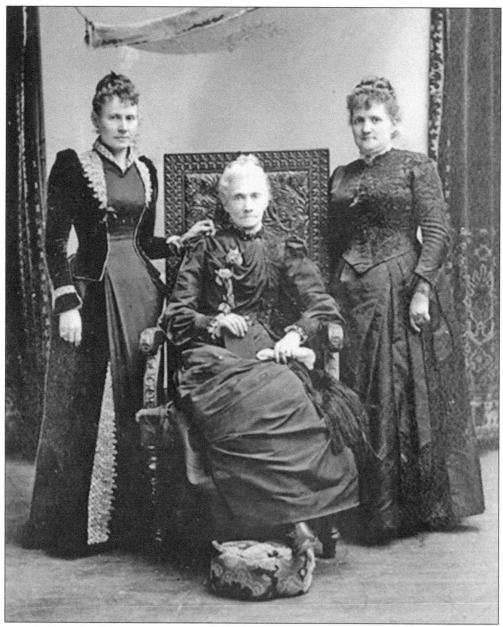

From left to right, these activists are Emily Richards (Plat Park-20-4-5-E), Sarah Melissa Granger Kimball (Plat E-12-14-2E), and Phebe Beatie (Plat I-22-9-2-E). All three fought for women's suffrage. In 1870, the Utah territorial legislature granted women the right to vote, preceded only by Wyoming in 1869. However, the US Congress revoked women's suffrage in Utah in 1887 as part of the Edmunds-Tucker Act, which aimed to eradicate polygamy through numerous restrictions on the church and changes to Utah's legal system. Richards spearheaded a territorial suffrage association affiliated with the National Woman Suffrage Association that successfully fought for women's suffrage to be included in the new Utah constitution in 1895. Beatie was the executive committee chair to the Utah Woman Suffrage Association as well as a delegate from Utah to the National Council of Women convention in 1891 and a member of the Relief Society general board.

Arnold Friberg (Plat X-6-206-2-E) was a Utah artist acclaimed for his patriotic, historical, and religious works of art. His best-known piece is *The Prayer at Valley Forge* (pictured), a realist painting of George Washington praying in the snow beside his horse. Friberg's depictions of stories from the Book of Mormon are also among his most popular works. He worked with the director Cecil B. DeMille to create historical paintings for the classic film *The Ten Commandments*, and the British royal family commissioned Friberg to paint Prince Charles and Queen Elizabeth II. Friberg died in Salt Lake City in 2010. (Fox.)

At the age of 57, Thomas Battersby Child (Plat West-11-24-3-E) began his work on the Gilgal Garden, a small, unique art space in Salt Lake City. The public garden contains 12 original sculptural arrangements and over 70 stones engraved with scriptures, poems, and philosophical texts. One of Child's sculptures in the garden, pictured here, depicts him with his tools. The Gilgal Garden is now maintained by Parks & Public Lands under a contract with the Friends of Gilgal Garden nonprofit organization, which handles renovation and conservation projects. Child died in 1963. (SLC Cemetery.)

Edward Woods (Plat West-7-132-1-E) was a stage and film actor most known for his role as Matt Doyle in *The Public Enemy*, starring James Cagney, and is pictured here with costar Joan Blondell. Woods later also produced and directed theater and movie productions, including training films for the US Army. He settled in Salt Lake City following his retirement and was buried in the Salt Lake City Cemetery in 1989. (SLC Cemetery.)

In the early days of photography and of Salt Lake City, C.W. Carter (Plat H-5-7-1-E) established a thriving photography business in the city in 1865. His expansive portfolio of portraits includes many of the images in this book and countless others of early Utahns who posed before his lens. He also photographed key Salt Lake City and Mormon sites that offer a fascinating insight into the late 19th century. Carter's photograph studio in Salt Lake City is pictured here advertising a variety of photograph types and prices. (DUP.)

Arthur Shepard (Plat West-3-108-4-E) was an alumnus of the New England Conservatory who led a musical career as a conductor and composer of over 100 symphonies, string quartets, songs, and hymns. (Marriott Library.)

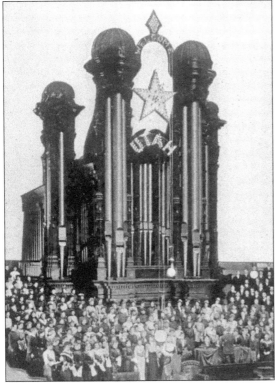

Edward Partridge Kimball (Plat I-22-9-4-E) was an organist of the Mormon Tabernacle Choir from 1905 to 1937. He and his son Ted were key to the advent of the *Music and the Spoken Word* program, which is still in production today. Pictured here is the famous tabernacle organ used in those programs. Kimball is also credited with either words or music on several songs in the church hymnal. He died in 1937 at the age of 54 while serving as the director of the church's bureau of information in Washington, DC.

John Widtsoe (Plat Park-33-2-1-E) was a prominent figure in Utah academia, furthering several agriculturally oriented programs at Utah State Agricultural College and Brigham Young University and working as president of the University of Utah from 1916 to 1921. He then served on the Quorum of the Twelve Apostles until his death in 1952. Widstoe published a variety of works: autobiographies, philosophical explorations of spirituality and the church, and agricultural studies. The math department building at the University of Utah is named after him.

Karl G. Maeser (Plat B-2-7-2-W) was an early Utah educator who founded the Brigham Young Academy and worked as its president for 16 years. Under his leadership, the academy educated several prominent Utah leaders and intellectuals, including US senator Reed Smoot. Keeping this school in operation was a continual struggle for Maeser but a passion to which he was committed throughout his career. The Brigham Young Academy evolved into Brigham Young University in 1903, two years after Maeser's death. His monument at Salt Lake City Cemetery was erected by a group of his pupils.

When the corpse of Moroni Clawson was discovered to be stripped of its burial garments, investigators discovered that Jean Baptiste, a cemetery grave digger, had robbed the grave as well as numerous others. Salt Lake City residents were outraged, and Baptiste was exiled to islands in the Great Salt Lake. Although no photographs of Baptiste are known to exist, this image illustrates the conditions of his exile. Church leaders buried clothes stolen by Baptiste in an unmarked mass grave in the Salt Lake City Cemetery's Plat B. (DUP.)

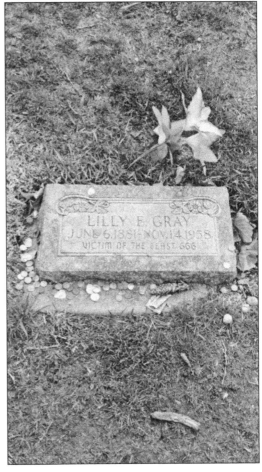

Lilly E. Gray (Plat X-1-169-4-E) is notorious in the Salt Lake City Cemetery for her headstone, which mysteriously reads "Victim of the Beast 666." The epigraph was chosen by Gray's mentally ill husband and likely refers to the government, which he blamed for Lilly's death. His gravesite lies as far away from Lilly's as possible, per his instruction. Lilly's tombstone also features devil's lantern flowers, a symbol of infidelity chosen by her husband. (SLC Cemetery.)

James C. Fletcher (Plat West-7-41-4-W) served two terms as the administrator of the National Aeronautics and Space Administration (NASA). Under his leadership, NASA launched three Skylab missions, two Viking probes to Mars, the Voyager space probes, the Hubble telescope program, and the Apollo-Soyuz mission that linked American astronauts and Soviet cosmonauts. Fletcher's second tenure as NASA administrator required him to lead the organization through the aftermath of the space shuttle *Challenger* accident. Prior to his career at NASA, Fletcher was president of the University of Utah. Here he stands at center in front of a space shuttle and its crew. Fletcher's headstone in the Salt Lake City Cemetery, where he was buried in 1991, artistically denotes these two passions by featuring the university's *U* and a space shuttle. (Marriott Library.)

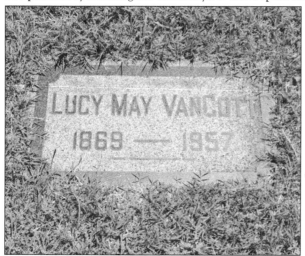

Lucy May Van Cott (Plat Park-1-21-4-E) was born in 1868, and after moving to Utah, received a scholarship and attended the University of Utah. She gained notoriety as a local teacher and principal and then returned to the university in 1907 as the first dean of women. In her 24 years in this position, she went on to establish several programs, including the first cafeteria at the university. In the foothills behind the university, a knoll named Mount Van Cott serves as a popular hiking destination for students.

Daniel Wells (Plat H-3-9NROD-1-E) was Salt Lake City's third mayor, from 1866 to 1876, the Deseret attorney general, and a member of the Quorum of the Twelve Apostles. In his religious life, Wells dedicated the temple in St. George, Utah, and twice served as president of the church's European mission. He issued Special Order No. 2, authorizing the extermination of Timpanogos Indians due to their conflict with pioneers settling the Salt Lake Valley. As a result, an estimated 102 Timpanogos people and 11 Ute men were killed. One of Daniel Wells's wives was Emmeline B. Wells, the esteemed activist for women's rights. Daniel Wells was buried in the Salt Lake City Cemetery in 1891. (Right, Fox; below, SLC Cemetery.)

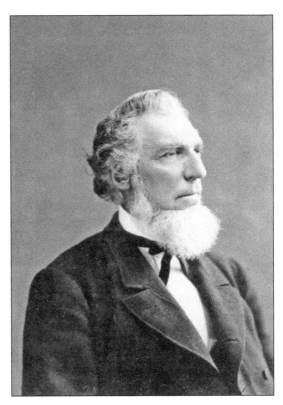

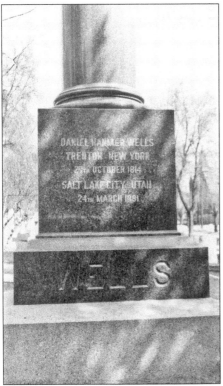

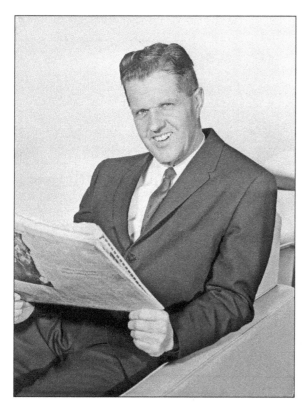

Conrad Harrison (Plat West-12-48-3-W) was the mayor of Salt Lake City from 1974 to 1976, filling a vacancy unexpectedly left by Jark Garn's departure for the US Senate. Harrison had previously served as a Salt Lake City commissioner and worked in the newspaper business as the managing editor of the *Logan Herald* and as music editor and general reporter for the *Deseret News*. His passion for music was evidenced by his membership in the Mormon Tabernacle Choir and authorship of *5,000 Concerts*, a book about the Utah Symphony. Harrison died in 2008.

Utah's first millionaire, William Jennings (Plat A-14-6-5-E), gained enough notoriety with his successful business enterprises to be elected mayor of Salt Lake City in 1882. He was deemed ineligible to seek a second term as mayor due to his practice of polygamy. His Eagle Emporium mercantile business was recognized at one point as the foremost retailer west of the Mississippi. This business was sold and became the foundation of Zions Cooperative Mercantile Institution (ZCMI). Jennings expanded and subsequently named the well-known Devereaux House, which hosted several visiting federal officials, including Gen. William T. Sherman.

John Milton Bernhisel (Plat B-15-10-5-E) was the first delegate of the Utah Territory in the US House of Representatives. He was very active in church affairs; prior to his political activity, Bernhisel studied medicine and was the personal physician to church founder Joseph Smith and his family. He was also a member of the Council of Fifty, an early church governing concept. (Fox.)

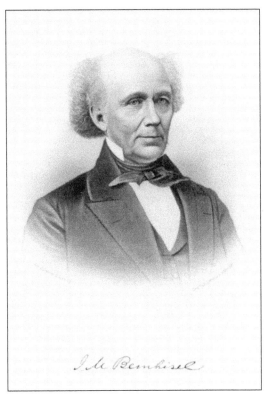

John Thomas Caine (Plat J-2-1-1-E) was a delegate to the US House of Representatives from the Utah Territory and a member of the Utah State Senate. Caine also served as the Salt Lake City recorder and was one of the founders of the *Salt Lake Herald* newspaper. The town of Caineville, Utah, is named after him.

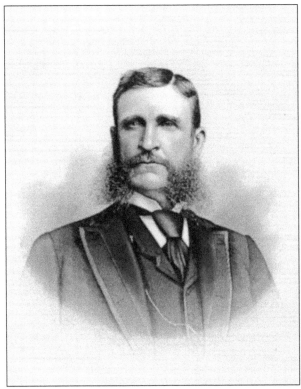

The Weber County, Utah, community of Hooper is named for Mormon pioneer William Henry Hooper (Plat J-8-1-2-W). As a Democratic delegate to the US Congress, Hooper represented the Utah Territory during debates surrounding statehood. During his nonconsecutive second term, he was called to be a member of the church's Council of the Fifty. Following his service in the House of Representatives, he became superintendent of ZCMI and later president of the Deseret National Bank until his death in 1882. (DUP.)

Joseph Lafayette Rawlins (Plat J-5-9-5-E) was born in the Utah Territory in 1850 to pioneer parents. He was an accomplished academic and attended Indiana University. He reportedly disapproved of the practice of polygamy and distanced himself from the church in his legal and political careers. Rawlins served as the at-large delegate to Congress from the Utah Territory and following statehood was elected to serve as a US senator. He was denied reelection to the Senate in favor of Reed Smoot in 1902. (DUP.)

When Utah gained statehood in 1896, its first governor was Heber M. Wells (Plat J-1-5-3-W). Governor Wells served two terms, from 1895 to 1905. He is shown here with Pres. Theodore Roosevelt. The building that houses the US Department of Commerce and the Utah Labor Commission in Salt Lake City is named in Wells's honor.

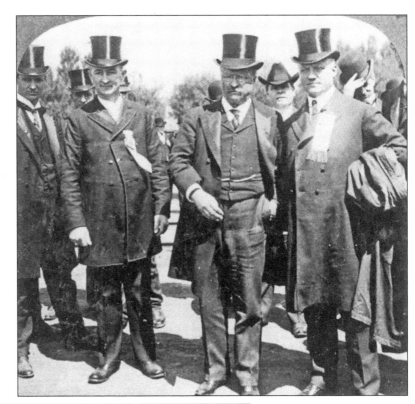

John Christopher Cutler (Plat H-CA-14-3-E) was the state of Utah's second governor, serving from 1905 to 1909. His ascension to the governorship was set into motion by a team of Republican politicians opposed to the Heber M. Wells administration. Cutler was successfully elected over Wells but did not win reelection to a second term. (Marriott Library.)

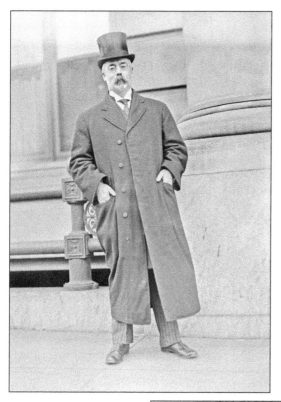

The third governor of Utah, William Spry (Plat Park-34-3-1-E), gained notoriety for his role in the trial of Joe Hill, a labor organizer who is widely believed to have been falsely accused of murder. Helen Keller, Pres. Woodrow Wilson, and Minister of Sweden to the United States A.F. Ekengren (Hill was a Swedish immigrant) appealed Hill's conviction, but Spry permitted his execution. Hill's ashes are scattered in all 47 of the other lower 48 US states; his dying wish was for his remains never to be left anywhere in Utah. A more positively viewed aspect of Spry's legacy is his work to persuade the Utah legislature to appropriate money for the state capitol. He was US land commissioner for the Interior Department, and the William Spry Agriculture Building on Redwood Road in Salt Lake City is named in his honor. Interestingly, his tombstone at the Salt Lake City Cemetery faces west, not north-south as most others do. (Fox.)

Calvin L. Rampton (Plat West-7-72-4-E) was Utah's longest-serving governor and the only person to be elected to and serve in that office for three full terms. Although noted as a popular and congenial politician, Rampton suffered several electoral defeats before being voted to the state's highest executive office. Upon his death in 2007, Rampton lay in state at a public viewing at the governor's mansion. The state capitol is the traditional location for this honor but was closed at the time for extensive renovations. His name was added to the Salt Palace Convention Center.

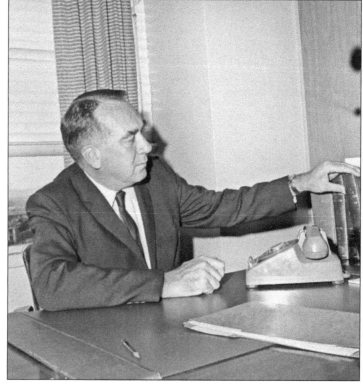

Joseph Morris (Plat B-Pauper-422) was an English convert to the church and arrived in Utah in 1853. He declared himself a prophet and petitioned Brigham Young to recognize his calling as the seventh angel of the apocalypse. Morris (left) and his followers, known as Morrisites, were excommunicated from the church and gathered at the abandoned Kington Fort. Reports of Morrisite kidnappings convinced the Utah territorial militia to investigate. A standoff ensued, and three days of skirmishes concluded with several casualties, including Morris. (Fox.)

William H. King (Plat F-4-14-2-E) was a Utah County lawyer and an associate Utah Supreme Court justice. He utilized his legal background and prior public service to be elected to the US Senate four times. During the 76th Congress (1939–1941), King served as president pro tem of the Senate. (Fox.)

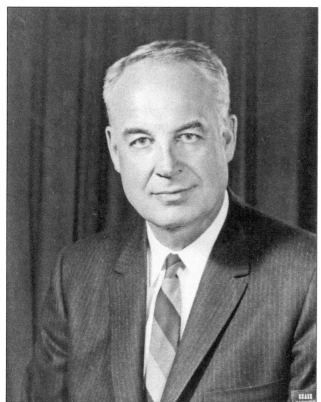

Sherman P. Lloyd (Plat West-11-122-4-W) was born in Fremont County, Idaho, in 1914. He had a storied career in commerce and politics. He is best remembered for his service as a member of the US House of Representatives in the early 1960s. In 1968, Rep. Gerald Ford visited Utah to campaign for Lloyd's unsuccessful nomination to become the Republican candidate for US Senate. Later in his life, Lloyd returned to his alma mater of Utah State University to lecture on law and politics. (Marriott Library.)

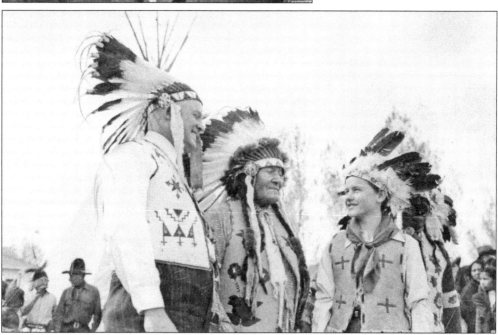

Gov. Herbert B. Maw (Plat West-1-12-3-E), at left, was a strong supporter of growing the Utah film industry and is pictured here on a movie set in Utah. He also left an enduring mark on the American political system by initiating the primary system for elections.

Elbert D. Thomas (Plat J-3-2-5-W) was a US senator from Utah from 1933 to 1951 and high commissioner of the US Trust Territories of the Pacific from 1951 to 1953. At the University of Utah, Thomas was a professor of political science and history. He also had a passion for theater and is pictured in a stage role with the Utah Dramatic Club.

Wallace Bennett (Plat West-11-90-5-E) was a US senator from Utah, serving three terms from 1950 to 1974. Senator Bennett was the ranking Republican on the Banking, Housing, and Urban Affairs Committee and on the Finance Committee. Several years after his retirement, Wallace Bennett's son Bob Bennett was elected to his former Senate seat. The federal office building in downtown Salt Lake City is named in his honor.

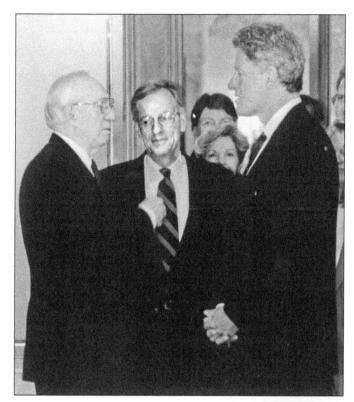

Utah politician Wayne Owens (Plat R-13-1-4-W), at center, served as a member of the US House of Representatives from Utah's Second Congressional District. His work on the federal water management project known as the Central Utah Project developed vital water infrastructure as well as power generation and recreational uses in Utah. Owens is seen here introducing Arkansas governor Bill Clinton to Gordon B. Hinckley, who was then serving as first counselor in the First Presidency, during a presidential campaign stop in Salt Lake City. (Courtesy of Stephen Owens.)

As Utah's first and, to date, only female governor, Olene S. Walker made strides in education initiatives. Walker served in the Utah House of Representatives from 1981 to 1989 and was majority whip. She was elected lieutenant governor in 1993 and passed key healthcare reform. Eleven years later, when Gov. Mike Leavitt moved to head the Environmental Protection Agency under Pres. George W. Bush, Walker was elevated to the governorship. She established the Olene S. Walker Institute of Politics and Public Service at Weber State University in 2012. (Fox.)

Seven

MEMORIAL AREAS

Throughout the Salt Lake City Cemetery are monuments to meaningful causes and events. Some are artistic sculptures, such as the Christmas Box Angel memorial for all children who have died, and others are unassuming markers with rich stories behind them, like the plaque dedicated to a group of Native Americans or the simple headstones of the old paupers' field. Special memorial areas in the cemetery also recognize cultural communities and veterans. The most visibly apparent of these is the veterans' area with its orderly rows of white grave markers. This area contains monuments for veterans of foreign wars, Civil War veterans, and gold star mothers, all of which attract crowds of visitors on Memorial Day each year. Japanese and Chinese characters can be seen inscribed on numerous headstones in pockets of the cemetery, reflecting how Utah's population expansion in the late 19th and early 20th centuries brought with it greater diversity thanks to immigrants from around the world. (Notable immigrants and members of minority communities can also be found with greater detail in chapter six. The sites listed in this chapter highlight a wide variety of the most interesting areas of the Salt Lake City Cemetery.

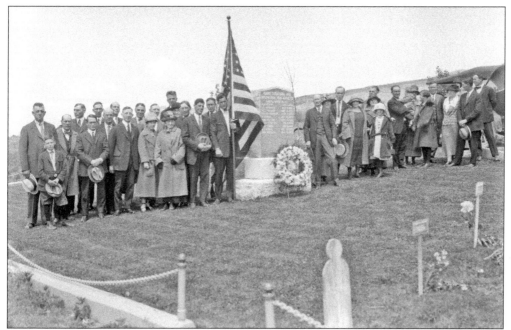

In March 1924, members of Local 27, Association of Bridge, Structural, and Ornamental Iron Workers, pose with a union monument in the Salt Lake City Cemetery. The monument (Plat U-34-4 to U-34-11) initially memorialized fallen union brothers from 1909 to 1922 and has received periodic updates over the years.

The paupers', potters', or strangers' field in a cemetery is a place where unknown or indigent people were traditionally buried. However, individuals who had means were sometimes buried in the paupers' field as well. The term "potters' field" is of Biblical origin, referring to ground where clay was dug for pottery, later bought by the high priests of Jerusalem for the burial of strangers, criminals, and the poor. Several notable individuals in this book are buried in the Salt Lake City Cemetery potters' field, including Jack Slade, Tom (slave of Abraham Smoot), and Gunplay Maxwell. (SLC Cemetery.)

The Canadian Legion is a veterans' organization for former Canadian service members, including those who have served in the military, police force, and Royal Canadian Mounted Police. The organization is most known for distributing Canada's remembrance poppies, which are worn nationwide by people young and old during the month of November in honor of Remembrance Day, a holiday akin to the American Veterans Day. This marker can be found in North Plat. (SLC Cemetery.)

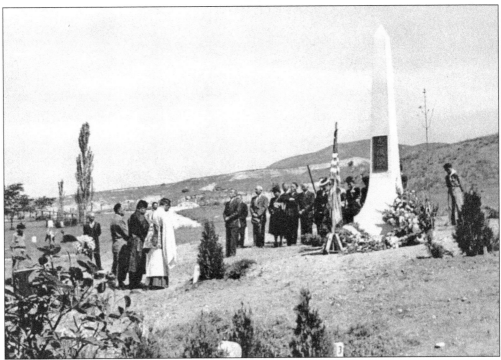

The World War II Japanese American Veterans Monument (North Plat) stands in the Salt Lake City Cemetery in honor of the Japanese Americans who served the 100th Infantry Battalion, the Military Intelligence Service, and the 442nd Regimental Combat Team. The 442nd Regiment is the most decorated US Army unit of its size in American military history. (Marriott Library.)

This 1947 photograph of stacked Chinese vaults highlights one way that different cultures blend their burial traditions together at the Salt Lake City Cemetery. The Chinese section of the cemetery has various markers and monuments to members of this ethnic group, many of whom came to the Salt Lake Valley as part of the expansion of the Union Pacific Railroad.

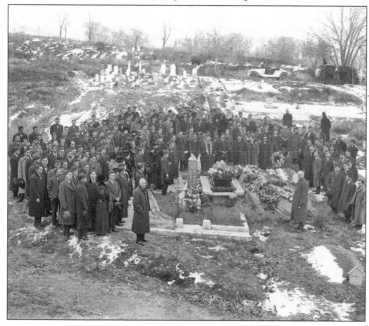

A large contingent from the Salt Lake City Japanese community attends the funeral of Yozo Hashimoto at the cemetery in December 1914.

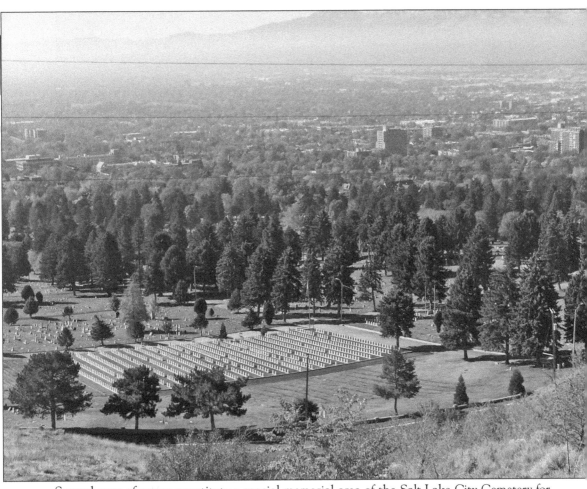

Several rows of graves constitute a special memorial area of the Salt Lake City Cemetery for veterans of the US armed forces. Veterans buried here served from the Civil and Spanish-American Wars up to current conflicts. During special holidays and events, this section of the cemetery is in full dress with American flags positioned along roadways and smaller flags on individual gravesites. (SLC Cemetery.)

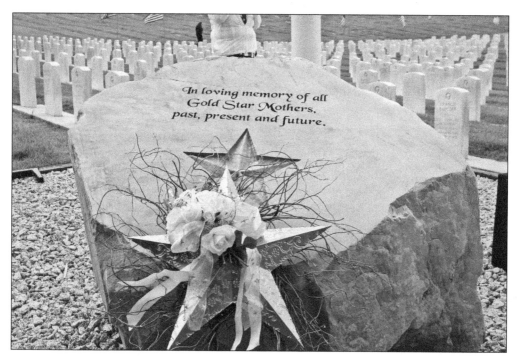

The Gold Star Mothers Monument (southwest corner of Plat Y-3) stands before the veterans' area of the Salt Lake City Cemetery. Dedicated in June 2010, this monument honors the many mothers throughout American history and in Utah whose loved ones have died in service. A bench just next to the Gold Star Mothers Monument bears an inscription reminding those who pass that freedoms enjoyed by Americans do not come without sacrifice. (Both, SLC Cemetery.)

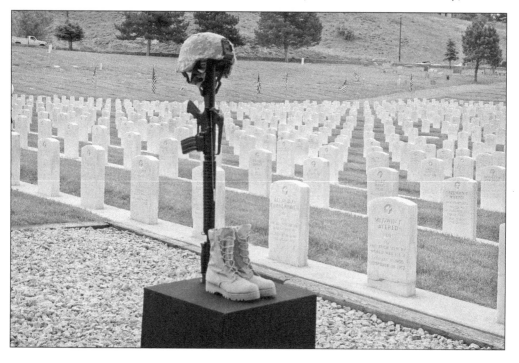

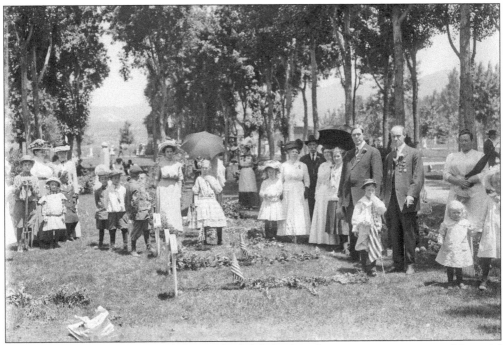

For decades, crowds have descended upon the Salt Lake City Cemetery to commemorate Memorial Day, paying respect to deceased veterans and showing their support for the armed forces and gratitude for sacrifices that service members and veterans make. A constant in Memorial Day gatherings and traditions continues to be the placement of American flags on graves, as shown above in 1911, when the holiday was called Decoration Day. The photograph below shows the gatherings at a more recent and typical Memorial Day weekend in 2014. (Below, SLC Cemetery.)

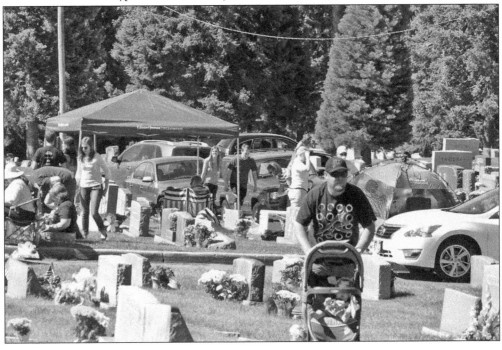

Two Congressional Medal of Honor recipients are buried in the Salt Lake City Cemetery. The above photograph of Frederick Jarvis's grave (Plat S-32-Single-51-E) notes that he received the Medal of Honor for his military service in the Apache Wars. Mervyn Sharp Bennion (Plat West-3-148-1-E), pictured at left, served as a captain in the US Navy and was killed during the Japanese attack on Pearl Harbor. He received a posthumous Medal of Honor, and the destroyer USS *Bennion* was named in his honor. The Congressional Medal of Honor is the most prestigious US military decoration, awarded to members of the armed forces who have gone above the call of duty and committed brave acts of valor at the risk of their own lives. (Above, SLC Cemetery; left, Fox.)

A monument was erected in 1919 to commemorate Utah Civil War veterans. During the Civil War, a cavalry unit led by Lot Smith (Plat B-15-27-3&4-E) served the Union army by protecting mail and telegraph routes on the Overland Trail. After the war's conclusion in 1865, many Civil War veterans settled in Utah; approximately 83 are buried in the Salt Lake City Cemetery and in Mount Olivet Cemetery. In 1999, the crumbling round river rock Civil War monument in the Salt Lake City Cemetery was replaced by a granite monument. The Sons of Union Veterans dedicated the new monument in remembrance of their ancestors who were part of the Grand Army of the Republic, a fraternal organization of Civil War veterans who supported the Union. The Sons of Union Veterans is responsible for the care of this monument and for holding memorial ceremonies, especially on Memorial Day. (SLC Cemetery.)

In the Japanese area of the cemetery, the dark-colored monument (Plat V-6-1-5-E) pictured here at right stands as a monument to the unknown dead. (SLC Cemetery.)

The Veterans of Foreign Wars in Utah maintain a monument (Plat L-42-4-5-W) at the cemetery for veterans who have served in overseas conflicts from the 19th century to the present. (SLC Cemetery.)

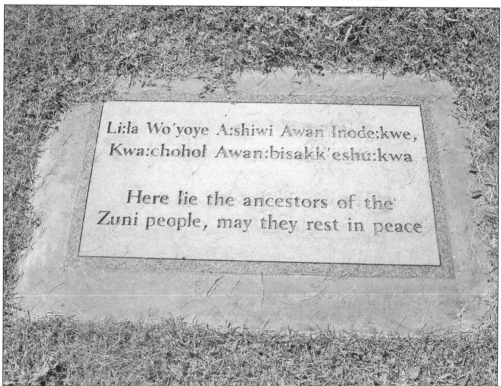

Li:ła Wo'yoye A:shiwi Awan Inode:kwe,
Kwa:chohoł Awan:bisakk'eshu:kwa

Here lie the ancestors of the
Zuni people, may they rest in peace

The Utah Museum of Natural History had served as a repository for the uncovered remains of people who were indigenous to the Salt Lake area. Upon a planned relocation to a new facility in 2008, museum directors partnered with the Salt Lake City Cemetery and local American Indian tribes to relocate the remains to one burial location. This small marker (North Plat-7-34-BTW4&5-W) indicates the place where these remains were put to rest. (SLC Cemetery.)

The University of Utah erected a monument (West Plat-12-132-2E2R) in honor of individuals who have donated their bodies for scientific research. Every year, a memorial service is held at this monument to pay respect to those who have made this choice, attended by many of their family members. At the 1998 ceremony, the local veterans pictured here played "Taps." Upon completed research and study, donated remains are cremated and either returned to family or interred at the Salt Lake City Cemetery. (Courtesy of the University of Utah Eccles Health Sciences Library.)

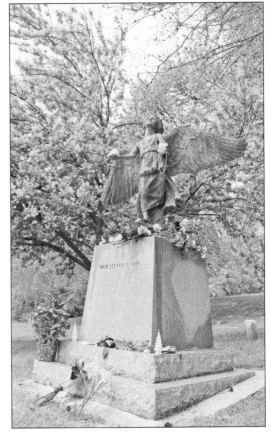

The Christmas Box Angel is a popular fictional holiday story set in Utah (355 North Center Street) that tells the story of a woman who mourns her child's death at the base of an angel monument. In the Salt Lake City Cemetery, an angel monument dedicated to all children who have passed away gathers mementos, flowers, and visitors all year round. Every year on December 6, a candlelight healing ceremony open to the public is held at this monument. (SLC Cemetery.)

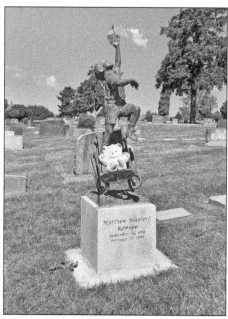

One of the most touching memorials in the Salt Lake City Cemetery depicts Matthew Stanford Robison (West Plat-6-130-1-W), who passed away before his 11th birthday. Matthew struggled with serious health issues since infancy. At his gravesite, a beautiful sculpture of a child reaching from his wheelchair toward the sky honors his memory with hopefulness, joy, and spiritual inspiration. (SLC Cemetery.)

At the cemetery entrance, 26 redbud trees were planted to memorialize each of the victims of the 2012 Sandy Hook, Connecticut, shooting. The redbud tree was selected by former urban forester Bill Rutherford and cemetery sexton Mark Smith for its small size, symbolic of the child victims; zigzagged twigs, symbolic of children's drawing style; and beautiful heart-shaped leaves. More generally, the trees symbolize new beginnings and growth and bring joy and improved quality of life to everyone around them. As the redbuds grow, they will reach across the sidewalk to form an arch, shading all those who enter and reminding cemetery visitors to remember those who were lost. A stone monument stands just inside the main cemetery gate reminding visitors that "life is precious, strength of the heart comes from the love we have and give to others." (SLC Cemetery.)

Eight

CEMETERY OPERATIONS

Most people come to cemeteries for funerals, but plenty of others also visit to walk or jog, some to read, and some simply to enjoy the peaceful surroundings. No matter their reason for coming, cemetery visitors see green expanses of mown lawns, diverse trees, flowers by gravestones, wildlife, and impressive views. What they do not see are all the intricate operations that have to happen to ensure that visitors have pleasant experiences.

For cemetery staff, their work is history in the making; what they are a part of is literally recorded in stone. Staff members are tour guides, arborists, researchers, equipment operators, grief counselors, historians, and more, wrapped into one. To do all of this in the Salt Lake City Cemetery is a very big job. This beautiful cemetery might offer one of the best vantage points of the city below, but the hillsides that create those picturesque views bring a lot of challenges for cemetery maintenance crews. To dig graves on hillsides can be challenging. To mow on hills and around the many headstones and trees is an art that often draws spectators. Also, those who trim around each and every one of the 124,000 headstones are regularly described as being involved in a meticulous labor of love. As the seasons change at the Salt Lake City Cemetery, so do staff's duties. In winter, nine and a half miles of roadways need to be plowed and salted so that funerals can continue to take place.

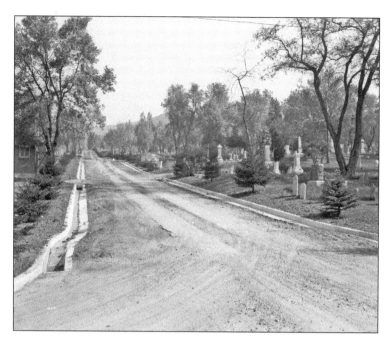

Center Street is a major roadway in the Salt Lake City Cemetery, cutting directly through the grounds north to south. In 1929, Center Street was graded in preparation for pavement. Today, the cemetery contains nine and a half total miles of paved roads, which greatly increases the funds needed for cemetery maintenance.

On Sunday, August 19, 1945, an extreme storm pounded Salt Lake City with hail and rain. A reported three-foot wall of water flowed across the cemetery, causing extensive damage to monuments, roadways, and trees. Over 100 homes in the surrounding Avenues neighborhood received flood damage, but no deaths as a result of the storm were reported.

These historic photographs show the meticulously maintained landscapes across the Salt Lake City Cemetery. Flowers, especially around the sexton's house, and a wide variety of trees populate the cemetery grounds. Since the cemetery was first established, horticulturists, landscape architects, and foresters have contributed to the planning, preservation, and maintenance of the diverse plants on its 120 acres.

The tradition of laying flowers on a grave has brought beautiful floral displays to the cemetery for decades, as seen in this vintage photograph of a bedecked casket. Staff leave floral arrangements at graves until they become unsightly, typically after one week. All flowers are also removed one week after Memorial Day, as the holiday brings an abundance of displays that interferes with daily maintenance and burials. Otherwise, cemetery staff do not touch or interfere with flowers or mementos left at graves. (Marriott Library.)

Mowing on hills and around all the upright headstones in the Salt Lake City Cemetery can be a challenge, but the highly skilled mowing crew treats it as an art form. Lawns at the cemetery are mown on a continuous basis; a crew will start mowing at one end of the 120-acre grounds, and by the time it reaches the other side, it must begin again. At a glance, this might seem like no big task, but there are more than 120,000 headstones to trim around and an elevation change of nearly 300 feet. (SLC Cemetery.)

Commitment to detail has always been an essential element of staff's approach to caring for the Salt Lake City Cemetery that has not waned over time. Thomas Penman is shown above in 1952 tending to a thriving flowerbed in the cemetery. Present-day groundskeepers also do detailed work trimming around the cemetery, cutting grass in hard-to-reach spots near monuments and maintaining a vast assortment of plants. (Below, SLC Cemetery.)

In 2007, a joint project between ONYX Construction Company and Salt Lake City restored the veterans' section in Plat Y-3 to prevent military headstones there from settling or sinking. This labor of love required drilling and placing rebar through all headstones, putting gravel underneath them, and pouring new cement collars around them. New topsoil was added and sod planted to complete this restoration as a place where family members can come and pay their respects to their loved ones. (SLC Cemetery.)

A cemetery crew is shown carrying out a burial in the middle of a snowstorm. It does not matter if it is snowing, raining, sunny, or foggy; the burial process at the Salt Lake City Cemetery is carried out no matter what, in all types of weather. (SLC Cemetery.)

Because the Salt Lake City Cemetery is situated on a fairly steep hill, with an elevation gain of close to 300 feet from Fourth Avenue to the south to Eleventh Avenue to the north, burials can be difficult and require the use of heavy equipment. It takes very skilled cemetery workers and all types of equipment to carry out burials on hillsides. (SLC Cemetery.)

In March 1961, a rash of vandalism occurred at the Salt Lake City Cemetery through Plat F and Plat N. Police conducted an investigation of extensive damage to both graves and headstones. Officials estimated that the total damage was several thousand dollars, as approximately 75 headstones were either tipped over or damaged. Headstones are considered private property in the Salt Lake City Cemetery, and visitors are urged to treat them with respect.

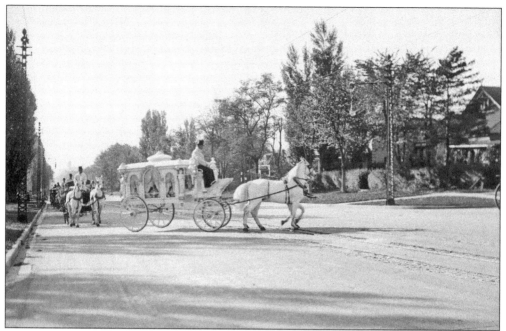

Horses and carriages formed funeral processions before the advent of automobile hearses. For the funeral of John Henry Smith, a former member of the Quorum of the Twelve Apostles and the First Presidency, this elegant procession transported his casket to the Salt Lake City Cemetery.

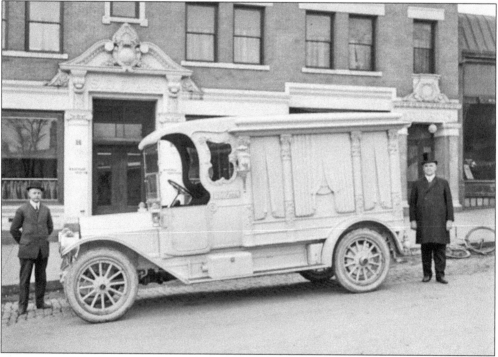

Once automobiles became widespread, auto hearses made their way to Salt Lake City. Several funeral homes acquired this new technology and switched over from horse-drawn carriages, including S.D. Evans, pictured here.

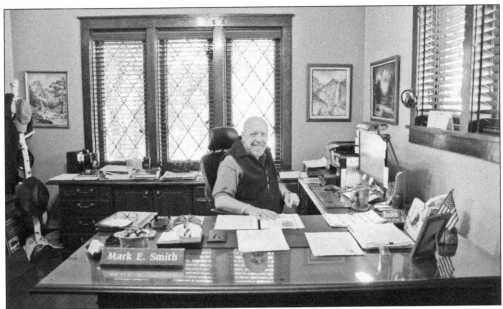

Many visitors to the Salt Lake City Cemetery arrive with a personal quest to trace their family history, and cemetery staff is able to assist with genealogical research about people buried on the grounds. Sexton Mark Smith himself searched through burial records to discover his great-grandfather Albert Smith, who died of cerebral hemorrhage in 1931. Anyone who digs through the history of the cemetery is likely to find their own favorite story—be it of a family member, a historical figure, a religious leader, or even an individual whose beautifully written epigraph or headstone strikes a chord. Smith, the cemetery's longest-serving sexton, encourages everyone to visit the cemetery in person to begin their own journey through the many stories contained within these 120 acres. (Both, SLC Cemetery.)

INDEX

ABOUT THE ORGANIZATION

The Salt Lake City Cemetery is a municipal cemetery administered by the Salt Lake City Public Services Department, the branch of Salt Lake City's government structure charged with being actively involved in diverse and daily vital services. This department aims to make lives better for residents and visitors by maintaining city infrastructure, managing public spaces, and supporting families with programming and events.

Since inception, the Salt Lake City Cemetery has been managed by a sexton. A sexton is the official title of the person who supervises all the operations of a cemetery. As of 2018, the staff that tends to the records and operations of the cemetery includes 12 full-time employees and up to 20 seasonal employees throughout the summer months.

In January 1851, an ordinance was passed by the Deseret General Assembly for "Incorporating the Great Salt Lake City." A city council was organized, and the Salt Lake City Cemetery was officially recognized. Since George Wallace was keeping the records of the cemetery, he was appointed the first official sexton.

In February 1856, Mayor Jedediah M. Grant instructed the Committee on Municipal Laws to create an ordinance for all people to be buried in a cemetery, not on private property, without the consent of the mayor and Committee on Municipal Laws.

Perpetual care is the general maintenance and repair of cemetery grounds. In the beginning, perpetual care was only offered in Park Plat, which was the newest area of the cemetery to be developed. In 1906, perpetual care was extended to the full cemetery, and by 1915, with the prolific growth of trees and shrubs, the hillsides resembled a forest. In 2014, the entire cemetery was placed on an automatic sprinkler system, and updates were made to cemetery ordinances.

Today, the mission of the Salt Lake City Cemetery is to serve families in their time of need and to be a good steward of the hallowed memorial grounds. The authors' royalties from the sale of this book are wholly contributed to a fund dedicated to the historic preservation and general maintenance of the Salt Lake City Cemetery.

Visit us at
arcadiapublishing.com